Thomas Edison
The Fort Myers Connection

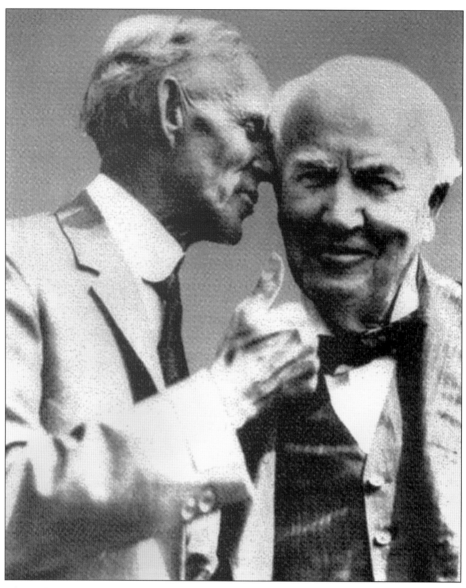

Through decades of friendship, Thomas Edison and Henry Ford maintained a strong respect for each other and a deep admiration for the other's achievements. Although Edison allowed few acquaintances to approach him within intimate distances, Henry Ford was one such person, as demonstrated in this photograph taken in the late 1920s. Throughout much of his adult life, Thomas Edison suffered acute deafness in his left ear and near-total deafness in his right ear. (Courtesy of the Edison-Ford Winter Estates.)

THE
IMAGES OF AMERICA
SERIES

THOMAS EDISON
THE FORT MYERS CONNECTION

IRVIN D. SOLOMON, PH.D.

ARCADIA
PUBLISHING

Published by Arcadia Publishing
Charleston SC, Chicago IL, Portsmouth NH, San Francisco CA

Printed in the United States of America

Library of Congress Catalog Card Number: 2001095513

For all general information contact Arcadia Publishing at:
Telephone 843-853-2070
Fax 843-853-0044
E-Mail sales@arcadiapublishing.com
For customer service and orders:
Toll-Free 1-888-313-2665

Visit us on the Internet at www.arcadiapublishing.com

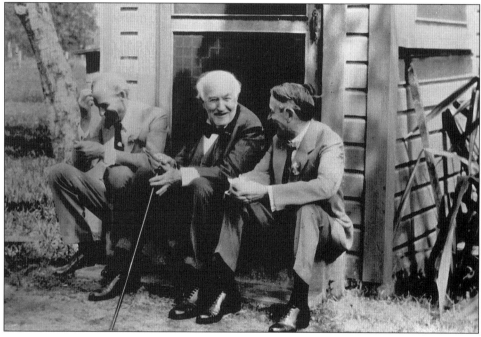

Model-T founder Henry Ford and rubber tire pioneer Harvey Firestone share a jocular moment with Thomas Edison on the stoop of Edison's rubber laboratory in Fort Myers, *c.* 1930. Throughout his life, Edison remained a connoisseur of fine jokes, a proclivity friends Henry Ford and Harry Firestone frequently played upon. Often, Ford and Firestone passed jokes to the hearing-impaired Edison on small cards, which may be the case in this picture (i.e., Ford appears to be holding a slip of paper in his left hand). This is one of the last pictures taken of the three friends together prior to Edison's death in 1931. (Courtesy of the Edison-Ford Winter Estates.)

CONTENTS

ACKNOWLEDGMENTS

As Americans moved into the new millennium, they spoke increasingly of the "Technology Revolution" and how it would change the nature of life. Indeed, the "Information Highway" and related developments have fundamentally altered the way we live and process ideas and information. Technology in its multifaceted applications demonstrably shapes our lives—for better or for worse—and the purveyors of the recent technological breakthroughs command positions of recognition and respect envied by most Americans and peoples around the world. Yet the foundation for recent technological developments occurred in an earlier age, most notably in the late 19th and early 20th centuries. It was that era in which the prototypical theories and structures of everyday technology reached unprecedented heights, and it was Thomas Edison who contributed the most to these developments. Edison not only invented and made practical many of the technological and communication devices integral to modern society, but he influenced the way that his and all ensuing generations have defined "progress."

This great inventor and historical figure lived a complex life, one that still intrigues and perplexes scholars and the general public. Although studied in finite detail for about a century now, few students of Edison have sought to illuminate his memorable years at his winter estate in Fort Myers, Florida from 1885 to 1887 and 1901 to 1931. This book offers a corrective to that often neglected aspect of the Wizard of Electricity's life. In this work, readers will find new information (in text and in captions) and incisive images of Edison's years, scientific work, and social activities in Fort Myers. This is the "Thomas Edison: Fort Myers Connection" that should prove enlightening to a wide range of readership.

Please note that the factual information contained in text and captions derived from research in primary sources, not all of which previous professional and amateur chroniclers of Thomas Edison and Fort Myers have fully mined. Thus, some of the information in this book may contradict earlier printed sources and persistent folklore. Such is the nature of historical scholarship, which is never infallible, as will be the case with this volume.

The challenges of completing a work imbued with both new detail and engaging images of Thomas Edison proved quite challenging. In the effort, I became indebted to several persons and organizations. I would like to give particular thanks to Leonard Di Graaf, Josh Runion, Theodore J. "Ted" Corbett, Ken Johns, James Haggler, Lori Van Wagner, Matt Johnson, Charles Dauray, Barbara Petyo, Laurel Gassman, and the entire staff of the Edison-Ford Winter Estates in Fort Myers. Estates director Judy Surprise tendered critical assistance and

support with her usual grace and effectiveness; without her professional courtesies, this work could not have been completed. Similarly, Fort Myers attorney and avocational historian J. Tom Smoot Jr. kindly shared information from his own extensive research on Thomas Edison and Fort Myers, which proved instrumental to the completion of this project, and journalist and author Lindsey Wilger Williams contributed both grammatical and historical strength to my work. Former Edison-Ford Winter Estates Museum educator James Gassman deserves my highest praise for his tireless guidance in my researching Estates' and related Edison archives for dusty information on Edison and Fort Myers and for his almost magical ability to recall facts, dates, and connections for the captions accompanying many of the images herein. Finally, I must reserve the most sincere form of praise for my wife, Betsy L. Winsboro, who for both this book and my life of the last 23 years has provided invaluable guidance and support.

Throughout the book, the following abbreviations are used to represent groups that have provided photographs:

EFWE	The Edison-Ford Winter Estates
ENHS	The Edison national Historic Site, West Orange, New Jersey
COLF	The College of Life Foundation, Inc., formerly The Koreshan Unity Foundation, Inc.
FMHM	The Fort Myers Historical Museum
TFL	The Tebeau-Field Library of Florida History

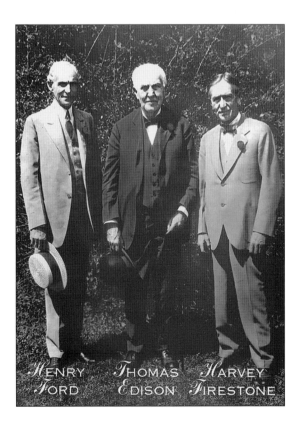

Early Fort Myers' most famous "threesome" pose in Thomas Edison's botanical garden at his winter estate, Seminole Lodge. This picture is particularly indicative of the three compatriots, because it shows them in their typical pose (Edison in the middle) and in their typical "uniforms" (formal attire), worn even during their leisure activities. (Courtesy of the Edison-Ford Winter Estates.)

INTRODUCTION

I find out what the world needs. Then I go ahead and try to invent it.

—Thomas A. Edison

The genius of Thomas Edison and his contribution to modern technology are integral to the history of the modern world. He is best known for his work in sound recording and electric lighting, but his 1,093 American patents also included pioneering work in numerous other scientific fields. Thomas Edison had gained worldwide acclaim for his business of "inventing" by the time he established a winter home in Fort Myers, Florida in 1885. Until his death in 1931, Edison spent many winter seasons in Fort Myers at his estate, known to his family and close associates as his "Florida Eden."

Today, Fort Myers recognizes Edison as its most famous "snowbird" and has made him a central figure in its civic promotion. The city now honors Edison's memory with a winter Festival of Light culminating with a popular Parade of Light and Pageant, numerous street and place names, a community college and a mile-long bridge named after him, and, most notably, a historic site and attraction named the Edison-Ford Winter Estates, which draws over 300,000 visitors annually. Indeed, Fort Myers has all but adopted Edison as its second persona.

Born in Milan, Ohio in 1847, and raised for much of his early life in Port Huron, Michigan, Edison showed signs of curiosity and genius at an early age. He created a prototype of an experimental laboratory in his cellar and learned the demanding skill of telegraphy at the age of 14. Although the telegraph remained Edison's mode of employment during his teenage years, experimentation and inventiveness monopolized both his thoughts and actions. By the age of 21, his endeavors resulted in his first patent, the "electrographic vote recorder." From this time forward, Edison subordinated almost all aspects of his personal and professional drive to a lifetime of invention.

Following his success as a talented and innovative telegraph operator, Edison departed the Midwest for the more favorable industrial and financial climate of the East coast. He moved to Boston in 1868, then to the New York City area a year later. There he concentrated on developing a vote recorder and a telegraphic stock ticker, both of which brought acclaim to young Tom for his uncanny ability to recognize and solve many of the engineering puzzles of his era. By the time the 38-year-old inventor visited Fort Myers in 1885, he had already secured 412 patents. By 1931, the year he died, Edison had received 1,067 patents or patent

reissues in his own name and another 22 patents in joint ventures, with the remaining 4 patents issued posthumously by 1933.

Edison created many of his early patented devices at his professional "invention lab" in Menlo Park where he relocated from Newark, New Jersey in 1876. It was here that the talented inventor and thinker proved so productive in the practical application of science that the public came to hale him as the "Wizard of Menlo Park." It was also Menlo Park where Edison moved his family, having married Mary Stilwell in 1871. They reared three children: Marion, Thomas Jr., and William.

Edison had purchased the property at Menlo Park for purposes of concentrating on the business of inventing. There he produced some of the most startling mechanical innovations of his era, including a carbon telephone transmitter and microphone, incorporated into Alexander Graham Bell's famous invention; the quadruplex telegraph; the electromotograph (loud-speaker telephone); the mimeograph; and the bipolar dynamo. He also began work on perhaps his two most original advancements—an incandescent electric lamp and a cylinder phonograph (a device for recording human voices). It was the search for a reliable incandescent (filament) electric lamp which would, however, overshadow Edison's myriad projects, until he discovered in October 1879 that a carbon filament in a vacuum provided a lasting thread of light.

Although many histories claim that Edison came to southwest Florida in search of tropical vegetation for use in his inventions, specifically bamboo as a possible carbon filament for the incandescent bulb, in probability Edison's spirit of wanderlust and lifelong interest in telegraph communications guided the inventor to southwest Florida. In 1884, his wife died, leaving Edison at the age of 37 an unexpected widower with three children. When Edison developed pneumonia during that winter, his physician advised recuperation from his emotional and physical problems in a warmer climate. Following his doctor's advice, Edison spent the winter in New Orleans and then St. Augustine, Florida, with friend and business partner Ezra Gilliland and his wife, Lillian. While in St. Augustine, Edison learned of a United States-to-Cuba telegraph cable whose underwater access started at the Caloosahatchee River port of Punta Rassa. The idea of visiting Punta Rassa intrigued Edison, who had begun his career as a telegraph operator. Although travel to Florida's southwest coast remained difficult in those days, Edison made his way by overland train from Fernandina to Cedar Key. At Cedar Key, he hired the yacht *Jeannette* to take him down the undeveloped Gulf coast to Punta Rassa.

Edison arrived at the Tarpon House (the former Shultz Hotel) at Punta Rassa in early March 1885, and quickly struck a friendship with George Shultz, manager of the hotel and the International Telegraph Company office in Punta Rassa. In a wide-ranging conversation on the hotel's veranda, Shultz offhandedly told the inventor about a rustic frontier town named Fort Myers 12 miles up the Caloosahatchee River where the tropical (technically sub-tropical) vegetation might be of interest to him.

In 1885, Fort Myers was perhaps the nation's southernmost frontier town, boasting a population of 349 residents. The hamlet was said to be rich with tropical vegetation, including palm trees, pineapples, citrus, and giant canebreak bamboo. Shultz's mention of giant bamboo, rare to the rest of Florida, possibly triggered Edison's curiosity and first trip to Fort Myers. His assistants had traveled the world to find a lasting fiber for his light bulb

filament. Was it possible the canebreak bamboo of Fort Myers would fill his needs?

Edison chartered the *Jeanette* on March 20, 1885 for an excursion up the Caloosahatchee River to explore Fort Myers, this bamboo-infested Shangri-la of the South. He arrived about noon and began an inspection of the village and environs that lasted through the afternoon of the following day. Edison found the tropical setting so fascinating and healthful that he immediately undertook negotiations for the purchase of a 13-acre riverfront tract, about a mile south of the city's business district, from Samuel Summerlin, son of cattle baron Jacob Summerlin. Edison's hasty but subsequent plans for a new winter estate on the Caloosahatchee called for complex landscape and construction projects, including shipping equipment from the Northeast to complete a laboratory and importing pre-cut hardwood lumber from Maine to construct his new home. Edison departed on March 21, 1885, promising to return, as the local newspaper recorded, "to do great things for Fort Myers."

In his New Jersey laboratory, Edison completed detailed plans for the preparation of his new winter retreat. The property would include a botanical garden (what Edison predicted would become his Florida "jungle"), two modest homes for Edison and the Gillilands, and plans, according to the *Fort Myers Press*, to install a 40-horsepower steam engine and a private workshop and laboratory. Edison also created plans for construction of a 357-foot wharf from his property into the scenic waters of the Caloosahatchee. His agent, Eli Thompson, arrived in November to supervise the clearing of the land, the sinking of pylons for the wharf, and the construction of more service buildings. Edison kept in close contact with Thompson through letters and telegraph messages.

While Thompson supervised these projects, Edison ordered more lumber for the present buildings from a Maine supplier, who loaded the spruce wood onto a schooner destined for Florida. The schooner arrived safely at Punta Rassa in January 1886, and its crew unloaded the supplies, but a second ship carrying machinery for Edison's planned Florida laboratory ran aground on the state's east coast. Nonetheless, Thompson oversaw the completion of the two houses, each with a large fireplace and pre-wired for electricity, and he assisted Edison's father, Samuel Edison, in assembling the laboratory building. Thus marked the inception of what was to become Edison's winter home and also one of the major historical sites and attractions of Florida and the nation.

If 1885 proved a pivotal time for the history of Fort Myers, so too did it prove a critical year for the famous inventor. In that year Edison determined to remarry and to build not only a new winter home but also a new family. In 1886, Edison married his second wife, Mina Miller, daughter of Akron, Ohio inventor-industrialist-philanthropist Lewis Miller, who with his wife, Mary Valinda, had been instrumental in the famous Chautauqua educational movement of western New York State. Edison and Mina had probably met in 1885 in New Orleans at the Industrial and Cotton Centennial Exposition, attended by Edison and the Miller family. Smitten by this "Maid of Chautauqua," after a seven-month courtship Edison, according to his biographers, proposed to her by tapping out Morse code on her hand in a carriage ride through the White Mountains of New Hampshire (the nearly deaf Edison had taught Mina Morse code early in their relationship). The gleeful Edison received Mina's acceptance, conditional on her parents' approval.

The wedding took place in February 1886. Mina was almost 20 years younger than Edison. The age difference made Mina's and Thomas's families skeptical of the success

of their relationship. Edison's first daughter, Marion, in particular, objected to her father marrying a woman so close to her own age. Edison's two sons, Thomas and William, lived with an in-law in Menlo Park, New Jersey and at first also had doubts about the new marriage. Nevertheless, Edison quickly built a strong, caring relationship between Mina and himself. The many critics of Edison's "autumn-spring" second marriage soon realized that Edison and Mina were especially suited for each other. One of Edison's first promises to his new wife was to take her to visit Fort Myers, Florida for their "special" honeymoon.

On March 15, 1886, Edison and his new bride arrived in Fort Myers aboard the Gulf steamer *Manatee* and stayed at the Keystone Hotel for three days while their new winter home underwent final preparations. The Edisons moved into their new home overlooking the Caloosahatchee on March 18. The usually taciturn Edison had little to say about the conditions, though Mina recorded her reactions to her new home in the "wild country" of Florida in a letter to her parents: "No running water, no sewage, no ice. Tough beef—no other meat. . . . No roads, no horses or carriages. We had a donkey, and a cart with one seat. A number of us sat at the rear of the cart dangling our feet when driving over bumpy fields of palmettos." Thus was Thomas and Mina Edison's introduction to the lifestyle of late 19th-century Fort Myers, a lifestyle that they would both help reshape over the course of their many decades there.

As the Edisons undertook the tasks of preparing the home and grounds to their desires, the town of Fort Myers sought to extend special recognition to its illustrious new winter guests. At first, the city fathers hoped to sponsor a "grand" reception for the honeymooners, but Thomas Edison in his own firm, but polite, way declined the reception and the public notice it would entail. Instead, officials received a request from Edison "for our people to make a sixty foot avenue from our city [Fort Myers] to his [Edison's] place on the Caloosahatchee. It would not cost more than $100, a good part of the job being already completed." Later, on March 25, the Edisons did allow the city band to play at the steps of their new home. The event impressed Mina, who is recorded as commenting that she had never before heard such "ethereal music." Even though a rugged and colorful deep Southern town in 1886, Fort Myers could still put on a show that impressed Northern sophisticates like the Edisons.

When Edison departed Fort Myers in 1886, he did not return to Menlo Park but rather to Llewellyn Park, New Jersey, where he had purchased a 23-room, Queen Anne–style mansion and 13.5-acre estate, known as Glenmont, to please his bride. The following year, he opened his West Orange, New Jersey laboratory and factory complex, which, combined with Fort Myers, would remain his primary sites of residence and work until his death. Even though the Edisons returned to their frenetic schedules in New Jersey—Mina to the work of wife, mother, and "home executive" and her husband to the labor of inventing, producing, and financing scores of new devices—Thomas Edison continued to oversee completion of his plans for the Fort Myers estate.

Edison-Ford Winter Estate records indicate that Edison intended to stay in Fort Myers four months a year during the cold New Jersey winters, although the press of business affairs often reduced his visits to much shorter periods. The Edisons' first winter in Florida witnessed the newlyweds devoting most of their time to preparing the modest house, now called Seminole Lodge, and tropical gardens for their future visits. Edison invested a great amount of time, as well, to supervising the construction and outfitting of his first Fort Myers

laboratory, completed in 1887. Mina's parents joined the Edisons at Seminole Lodge in early April of that first winter season. Perhaps the Millers meant to help their daughter adjust to the new marriage with the older Thomas Edison and to comfort her in the rustic town of Fort Myers. The two couples enjoyed their new surroundings and their company until their joint departure north in late April. During his stay, Edison recorded in his notebook that he spent his private time working on his phonoplex, quadruplex telegraph, and telephony systems and searching for what he termed the electric "earth currents" that constantly passed through the Earth's crust, especially through areas of low-mineral sand (this seems to be one of Edison's scientific interests unknown to many of his devotees). The Edisons returned to Florida during the winter of 1887 and spent their first entire season at the newly completed Seminole Lodge.

On March 27, 1887, most of Fort Myers' residents saw their first electric lights, complements of their renowned winter guest. Edison transported a dynamo to Fort Myers that winter and used it to illuminate Seminole Lodge. This marked a history-making event for the village, and excitement began to build as Edison vowed to provide lighting for the streets of Fort Myers. The *Fort Myers Press* noted: "Mr. Edison has the electric light. . . . To the many inquiries at home and abroad: 'When will Edison light our town?' We answer we do not know, but hope to announce the fact in a short time."

However, Edison's lighting of the streets of Fort Myers was much delayed. The Edisons left Fort Myers in early May 1887 and did not return until the winter of 1901. Within weeks of their departure from Seminole Lodge, a yellow fever epidemic caused Fort Myers to undergo quarantine. This probably convinced Mina Miller Edison, now expecting the couple's first of three children (Madeleine, Charles, and Theodore), that it would be unwise to take youngsters to southwest Florida anytime soon. During the next 14 years, Mina elected to stay in New Jersey to raise her three young children (Thomas Edison seldom involved himself personally in his family's affairs). A prolonged legal dispute between Edison and long-time associate Ezra Gilliland also demanded Edison's presence in New Jersey for most of the 1890s. Even so, Thomas Edison continued to supervise the upkeep of his winter home and gardens in Fort Myers. This is strong indication that Edison hoped to return to southwest Florida at a future date. The family did return to Fort Myers for most of the winters after 1901, staying about six weeks and extending that period by months during the inventor's waning years.

When Edison bought the Fort Myers property, he drew a plan for the gardens of Seminole Lodge. It is now evident that he was unaware of how the Florida climate would affect Northern plant species. Edison learned by trial and error which species would thrive and which would succumb to the Florida sun. Occasionally, he did some minor experiments on the various plant species but found little of use to him. The giant bamboo that originally brought him to Fort Myers proved inferior for his purpose, stimulating him to eventually adopt an imported Japanese variety of bamboo for his incandescent bulb. In retrospect, Edison's interest in the flora and fauna during his years in southwest Florida remained linked as much to his gardening and fishing interest as to his scientific goals.

As an outgrowth of his gardening hobby, Edison became intrigued with the unusually large royal palms bordering the majestic Royal Palm Hotel. They had grown to an enormous height and girth, prompting Edison to use some to beautify his own estate. Edison's

infatuation with the tropical palms moved him in 1907 to propose to the city that he could have royal palms planted on both sides of Riverside Avenue (now McGregor Boulevard) south of his estate to Manuel's Branch, a distance of just over one mile. He promised to maintain them for one year, after which the city would assume that responsibility. It is the legacy of Edison's various attempts to import and plant royal palms from Cuba that visitors see lining McGregor Boulevard as they approach the Edison-Ford Winter Estates. Locals became so enthralled with the Edison/palm connection, that Fort Myers promotes itself as the "City of Palms."

During Edison's winter vacations in Fort Myers, he frequently granted interviews to reporters for the local newspapers. On occasion, wire services and major newspapers throughout the United States reported "Prof. Thos. A. Edison's" comments about Fort Myers. Many of these interviews brought national recognition to the village of Fort Myers, making the area a new playground for the nation's wealthy. For example, in March 1914, the *Fort Myers Press* quoted Edison as saying, "There is only one Fort Myers in the United States, and 90,000,000 people are going to find this out" (the 1910 Census enumerated just over 91,000,000 persons in the United States). The interview continued with Edison claiming, "It [Fort Myers] is looking better today than ever and I have made up my mind that I will not let a year go by without coming to it. It has a wonderful future." Edison granted an interview in 1916 to a reporter while the Edison family traveled to its New Jersey home. Again, the wire services disseminated Edison's positive comments nationwide about the future of Fort Myers:

> *The future of Ft. Myers is assured. Within the next very few years solid business blocks and beautiful winter estates will line the Caloosahatchee. . . . No spot in Florida, and by that I mean the United States, can compare in natural beauty and climate with that possessed by beautiful Ft. Myers. . . . This city is bound to grow—and grow rapidly—and I predict what to some may prove startling development in the course of the next 10 years.*

When the news services picked up these stories, a contest for tourists and winter residents evolved between the new boomtown of Fort Myers and the more noted Miami area on the east coast of Florida. Apparently, Miami had not previously considered the Gulf coast competition for Florida's tourism industry. The Edison-Fort Myers connection changed all that.

Edison's endorsements led other famous people to the Fort Myers area—either to visit, sport-fish, or to spend their winters. Ambrose McGregor, associate of John D. Rockefeller in the Standard Oil Company, and his civic-activist wife, Tootie, visited Fort Myers in late 1891, and eventually bought the house next to the Edisons' estate. Now one of the richest and one of the most famous men in America had winter homes in Fort Myers. By the turn of the century, McGregor's and Edison's combined influences attracted some of America's most affluent persons to Fort Myers, Florida.

Henry Ford, the originator of the Ford automobile empire, and John Burroughs, the widely acclaimed writer and naturalist, accompanied Edison to the city in 1914. Ford bought a home (known as The Mangoes) in Fort Myers and often spent winters there visiting his mentor and best friend. Former President Theodore Roosevelt visited the area in March 1917, in hope of capturing the giant "devil ray" (manta ray) and completed lengthy articles

about his experience in southwest Florida for *Scribner's* magazine and *The American Museum Journal*. About the same time, Akron, Ohio rubber magnate Harvey Firestone began a series of visits to the Fort Myers winter notable, and even president-elect Herbert Hoover once visited the tropical city to salute Thomas Edison. In this manner, through Edison's efforts and fame, humble Fort Myers both attracted visitors of national recognition and catapulted itself into the national limelight.

Fort Myers lost its greatest booster and benefactor in the early morning hours of October 18, 1931, when the 84-year-old Thomas Edison died of a chronic illness. Even during his advanced stage of infirmity, the indefatigable inventor continued to investigate practical mechanical and scientific advancements, including intensive work on finding a domestic source of natural rubber in his Fort Myers laboratory. In 1947, Mina Miller Edison deeded the Edison winter property and Thomas Edison's final research facility, the rubber lab, to the City of Fort Myers to be used in perpetuity to honor the great American inventor. Shortly thereafter, the property and house opened for public tours, quickly attracting crowds in the tens-of-thousands. By the turn of the millennium, the famous "Florida Eden" of Thomas Edison drew in excess of 300,000 visitors annually, stark testimony to the intriguing historical association between Edison and Fort Myers.

The results of Edison's impact can be seen, in part, in the statistics of Fort Myers. At the turn of the 21st century, the Fort Myers area ranked among the United States' top ten growing metropolitan areas, with a population of almost one-half million and a "high-season" winter population of over one million. Tourism, the magnet that drew Edison to southwest Florida in 1885, accounted in the year 2000 for 1.86 million visitors to the area who generated more than $1.63 billion in economic activity. Essentially, the same factors that attracted Edison and subsequent luminaries to Fort Myers were still at work at the turn of the millennium: mild winters, beautiful waterways, and exotic flora and fauna. Longtime residents of Fort Myers are fond of calling their winter visitors from the North "snowbirds." In retrospect, the original Fort Myers' snowbird was none other than the most famous American of the late 19th and early 20th century, Thomas Edison.

1. MAN OF THE MILLENNIUM

I would like to live about three hundred years. I think I have ideas enough to keep me busy that long.
—Thomas A. Edison

In the fall of 1997, *Life* magazine selected Thomas A. Edison as the "Man of the Millennium." In explaining its choice of Edison as first among "The 100 People Who Made the Millennium," *Life* captured the essence of the renowned inventor's contributions to humanity: "Because of him, the millennium will end in a wash of brilliant light rather than in torchlight darkness as it began." While scholars and common folk will probably be arguing about the credibility of this selection for another millennium, there can be no doubt that Edison remains almost unparalleled in achievement during this critical segment of history. In our time alone, Edison has been the subject of innumerable books, biographies, studies, and documentaries, perhaps more so than any other single American. Every American teacher, student, and parent can identify and expound upon the greatness of Thomas Edison, and every American can trace the imperatives of his and her lifestyle to one of Edison's inventions, developments, or ideas. There simply has been no other American, or perhaps world figure, of the last millennium whose ingenuity and creativity so dramatically affected the nature of our lives.

Even given Edison's greatness, many Americans are hard pressed to fully and accurately describe the contours of his life. How many school children and adults alike can recite the story of this grand American's boyhood and meteoric rise to prominence in the world of inventive technology and subsequent production of "useful" goods? How many Americans can illustrate his relationship to the work ethic and to the direction in which it took his career? How many Americans can describe the personal victories and tragedies that so demonstrably affected Edison's life and thinking? In short, Edison remains an enigma to many Americans.

Yet there are many meaningful events of Edison's life and times that are easily grasped and recalled by those interested in this subject. As noted in the Introduction to this work, Edison received 1,093 U.S. patents, or shared patents, for creating or improving many of the original devices that shape our lives today. As recorded in the *Journal of the Patent Office Society*, Edison

won patents in an incredible array of fields, including:

Electric light and power, 389	Ore separator, 62	Automobile, 8	Military projectiles, 3
	Cement, 40	Electric pen and	
Phonograph, 195	Telephone, 34	mimeograph, 5	Radio, 2
Telegraph, 150	Railroad, 25	Typewriter, 3	Rubber, 1
Battery, 141	Motion Pictures, 9	Chemicals, 3	

By securing patents for every year from 1869 to 1933 (four of Edison's patents were issued posthumously), Edison ensured his legacy as one of the world's greatest creative talents.

Thomas Edison is arguably the most productive and widely recognized inventor in history. His dedication to the philosophy that "a good idea was never lost" resulted in innumerable products taken for granted by modern societies. Indeed, the fertile mind and diligent work habits of Thomas Edison have affected the modern world in ways perhaps not matched by any other single person. Edison's genius was not only his gift for solving technological riddles but also for converting the fruits of his labor to "useful" and "practical" implements of everyday life. Following the successful experiment with a filament light bulb, Edison remarked, "I shall make the electric light so cheap that only the rich will be able to afford candles."

During his childhood, Thomas Edison received much of his basic education at home from his doting mother, Nancy. Mrs. Edison assumed the responsibility for educating young Tom after his former teacher in a private school called him a problem child. Throughout his life, Thomas Edison maintained that formal education had not made him, nor others like him, but rather the determination to read voraciously (how often does one think of Edison as reading four newspapers a day and enjoying the works of Victor Hugo, Jules Verne, and William Shakespeare?), an innate curiosity, the desire to experiment, and perseverance actually laid the groundwork for his lifetime of success. Those traits nurtured his work habits and philosophy throughout life.

Lacking a formal education both shaped and hindered Edison's life. More important to Edison's success than a structured education were his "practical" schooling as a youthful newsboy, railroad worker, and telegrapher, and the independence of mind and habit that led him to solving, or attempting to solve, many of the industrial and technological mysteries of his time. Yet it was the very success engendered by Edison's inner qualities that also led to his lifelong financial and legal problems that proved so vexing to him. Though possessing a keen and quick mind, Edison's lack of formal education hindered his ability to reason and to communicate at the highest levels of successful entrepreneurship.

Perhaps Edison's lack of formal education, and even his progressing deafness, discouraged his intimacy with a wide range of friends and acquaintances. Whatever the reason, Thomas Edison lived a life of few deep personal ties. Interestingly, two of his most notable relationships occurred during his Fort Myers connection years, the devoted husband–wife relationship he orchestrated with second wife, Mina, and the mentor-student relationship he maintained with kindred inventor, Henry Ford.

Edison received many awards and medals for his inventions and products but took the most pride in the Congressional Medal of Honor, presented to him in October 1928. Congress

voted to inscribe the following words on the celebrated inventor's medal: "He Illuminated the Path of Progress by His Inventions." His inventive genius has not only stood the test of time, it has grown in significance over the generations since he received the Congressional Medal. Edison always wanted to create, improve, and produce the most useful and lasting of products. As Edison boasted, "If it is not the best materials, the best effort, and the best product, it will never have the name Edison on it." This work ethic is the reason that so many of his developments are still integral to life in the 21st century.

For those readers interested in a deeper understanding of the unique Thomas Edison-Fort Myers connection, his background, personal qualities, and intriguing relationships with Mina, Ford, and other notables, this work will prove useful. Readers will soon come to realize in these pages that Thomas Edison was a complex person—a hard worker yet an avid botanist, naturalist, and camper; a taciturn, sometimes aloof person, yet one who enjoyed a practical joke among friends and co-workers; a sardonic commentator at work and at home, yet a benefactor of and role model for his family, employees, and community. Fort Myers, Florida never had, nor possibly may ever have, such a cherished yet enigmatic relationship as it experienced with its "most famous snowbird," Thomas Edison.

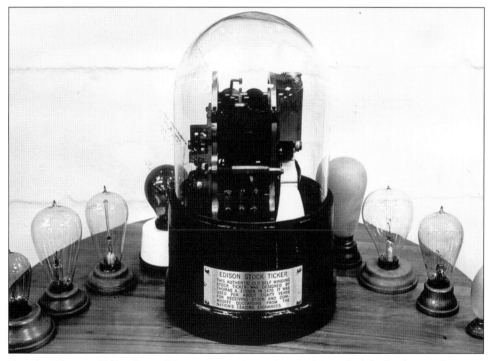

Despite Thomas Edison's prolific success at invention in his early life, his biographers are quick to point out that the stock ticker device probably generated the first measurable income for the young inventor. Edison transferred the patent rights of his improved stock ticker to a Boston business consortium in 1869 and promptly reinvested that financial largess into other speculative ventures. (EFWE.)

Thomas Edison is pictured at age 14 in 1861, the year the Civil War broke out in the United States. During most of the Civil War, young Tom worked as an itinerant telegrapher in the Midwest. Shortly after the war, Edison moved to Boston where he transformed himself from an amateur to a professional inventor. (EFWE.)

This classic picture—actually an ambrotype—of "Young Tom" Edison is now housed at the Edison National Historic Site in West Orange, New Jersey. (ENHS.)

18

While searching for the answer to another problem, Thomas Edison discovered what has been called the "Edison Effect" in 1880. This phenomenon revealed the fundamental principle on which rests the modern art of electronics. (ENHS.)

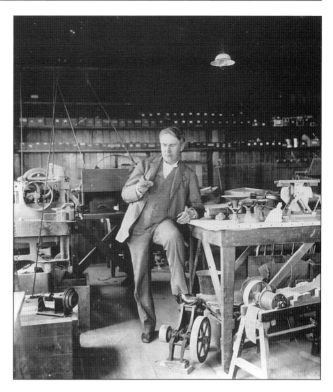

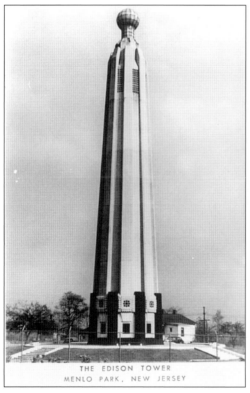

THE EDISON TOWER
MENLO PARK, NEW JERSEY

Built on the spot where Thomas Edison activated his first electric light bulb, the Menlo Park Tower Monument stands today as testimony to both Edison and his startling invention of October 21, 1879. On that day, Edison perfected the incandescent lamp, which served as the prototype for all the following developments in electric lighting. Although the Tower does not contain the original lamp, it does display the light that Edison switched on in 1929 to commemorate the golden anniversary of his 1879 advancement. (ENHS.)

19

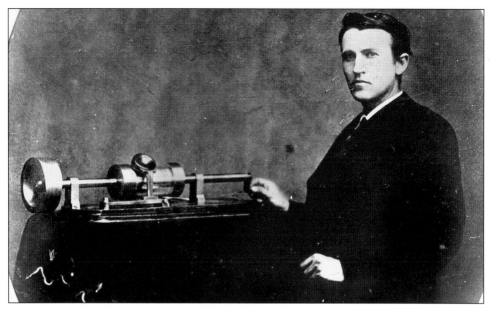

Thomas Edison often boasted that he enjoyed working on the phonograph and its spin-offs more than any other invention. Despite popular myth that Edison initially developed the phonograph for entertainment, in actuality he developed it "for the businessman to organize his daily activities." This photograph of Edison in 1878 shows him demonstrating his tinfoil phonograph, perhaps very much like the one he played for President and Mrs. Rutherford B. Hayes in the White House that year. (EFWE.)

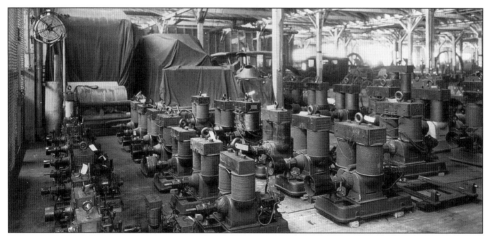

This is a view of the "Old Edison Bipolar Dynamos," which at one time produced electricity for much of the eastern United States. Edison's first generation of dynamos, the "Long-waisted Mary Ann," gave way to a second generation of "Jumbo" generators with a capacity of 1,200 hundred lights, more than four times the capacity of the previous generation of dynamos. Samples of Edison's dynamo may be seen at both the Edison-Ford Winter Estates Museum in Fort Myers, Florida, and at Greenfield Village in Dearborn, Michigan, the location of this dynamo display. (EFWE.)

Together with the electric lamp, the phonograph remains one of Edison's most original and widely used inventions. Edison developed the first phonograph in Menlo Park, New Jersey in 1877, but that tinfoil cylinder model eventually gave way to a wax cylinder improved model ten years later. As legend goes, Edison's first voice recording was that of "Mary had a little lamb," the nursery rhyme so popular in his era. (EFWE.)

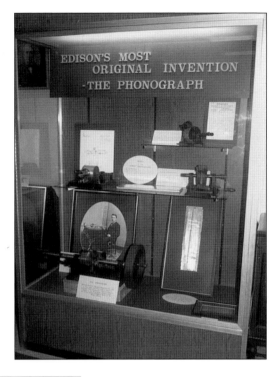

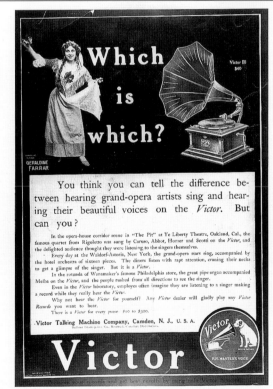

The genius of Thomas Edison did not always result in financial profits. In his maturing years, Edison particularly lamented the financial loss of the phonograph, which the Victor Talking Machine Company marketed as the Victrola. This machine relied on a convenient disk at a relatively inexpensive price, which quickly surpassed Edison's phonograph in sales. Although Edison continued to improve his own recorder, he lost out in market shares to the Victrola as he insisted on emphasizing quality over price. (EFWE.)

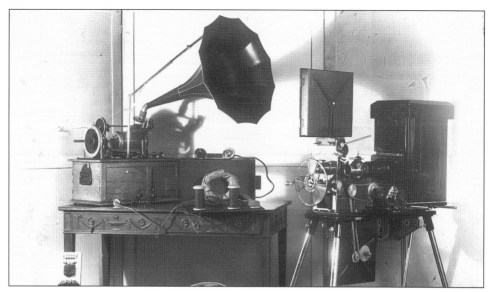

In this visual juxtaposition of the phonograph and movie projector, one can fully appreciate Edison's refining the motion picture projector—"I wanted the movie projector to do for the eye what the phonograph did for the ear." He developed the kinetoscope in 1891, and sought to add sound to the motion picture projector in his kinetophone in 1913. These items are in the Edison-Ford Winter Estates Museum in Fort Myers. (EFWE.)

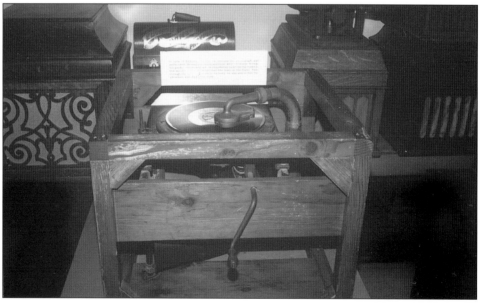

Even though hearing impaired, Edison pioneered the phonograph. The wooden frame on this version of his phonograph discloses bare wood on the upper brace—the telltale sign of his testing for recording quality. He would bite down on the wooden rack as the record played and receive the sound through bone conduction, through his teeth, jawbone, and bones and cochlea of his ear, allowing him to determine sound quality. (EFWE.)

This version of the Edison typewriter used a disk of characters to transmit print. Note the "CHARS" and "CAPS" designation on the lower disk. Edison received multiple patents on this typewriter. A model of the original can be seen at the Ford Museum in Dearborn, Michigan. (EFWE.)

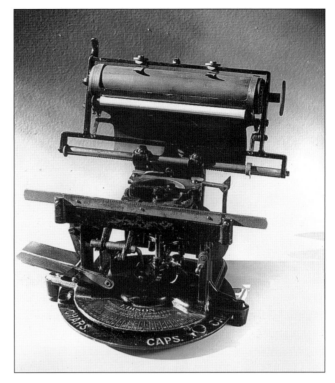

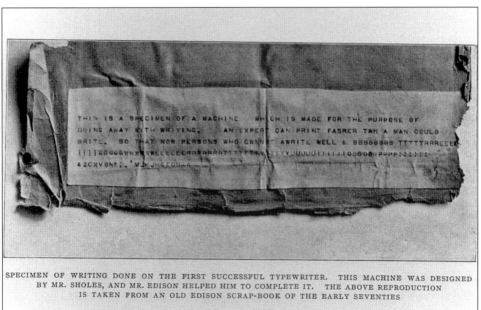

SPECIMEN OF WRITING DONE ON THE FIRST SUCCESSFUL TYPEWRITER. THIS MACHINE WAS DESIGNED BY MR. SHOLES, AND MR. EDISON HELPED HIM TO COMPLETE IT. THE ABOVE REPRODUCTION IS TAKEN FROM AN OLD EDISON SCRAP-BOOK OF THE EARLY SEVENTIES

Edison might have held a special fascination for the typewriter concept because of the role its keyboard could play in his numerous other inventions designed to transcribe automatic messages. In the late 1880s, the A.B. Dick Novelty Company marketed an improved Edison stencil typewriter known as the Edison Mimeograph. (EFWE.)

This early version of the typewriter machine, *c.* 1872, became the forerunner of Edison's electrical printing machine and electrical typewriter. In 1872, he received multiple patents for his printing telegraphs and printing telegraph instruments. As a result of his work on the original Sholes machine, Edison received three patents for his improved typewriter. Although not the inventor of the typewriter, he made it practical for mass markets, as he did with so many of his discoveries and improvements. (EFWE.)

Sitting in his private chair in his massive library at West Orange, New Jersey in this *c.* 1910 picture, Thomas Edison exudes an air of confidence and achievement. (EFWE.)

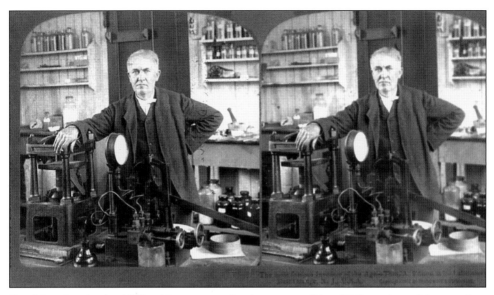

Possibly taken in the 1890s, this stereoscopic viewmaster slide of Edison shows him standing next to a press in his New Jersey laboratory. The picture's caption identifies this as the East Orange laboratory, although it more likely is the West Orange lab. (ENHS.)

In January 1886, Edison purchased the former Pedder estate in Llewellyn Park, West Orange, New Jersey as a gift for his new bride, Mina Miller Edison. He paid $125,000 for the 23-room, Queen Anne–style house and its 13.5 acre estate, known as Glenmont. The promoter billed it as a "Country House for City people." The magnitude of the house and purchase led Edison to quip, "To think it was possible to buy a place like this. . . . It is a great deal too nice for me, but it isn't half nice enough for my little wife here." (EFWE.)

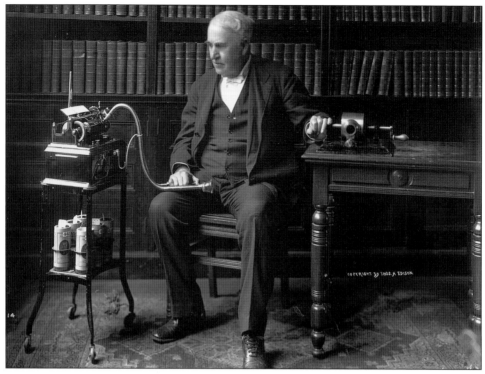

At age 66, Thomas Edison posed with two of his early inventions, the tinfoil phonograph and the Edison voice recorder dictating machine. This picture is in West Orange at his office and library, which reportedly contained over 10,000 volumes. (ENHS.)

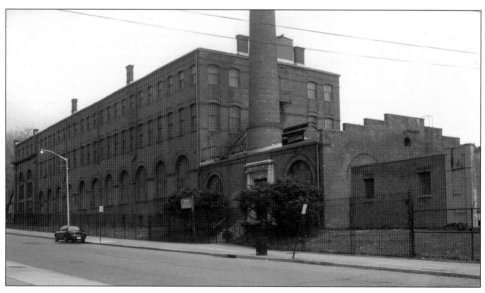

Once used as the main building of the Edison complex in West Orange, New Jersey, this is what the three-story laboratory looked like 70 years after the death of its founder and director. (Courtesy of James Gassman, Museum Educator, Edison-Ford Winter Estates.)

In this pre-1923 picture, the self-trained Thomas Edison and the brilliant German-born mathematician and engineer Dr. Charles P. Steinmetz, collaborated on solving an electrical-mechanical puzzle. Edison is best known for originating the theory of direct electric current, while Steinmetz is remembered for developing the theory of alternating current. This disabled yet brilliant scientist soon surpassed Edison as the authority on electricity transmission and contributed much to the rise and success of the General Electric Company. (EFWE.)

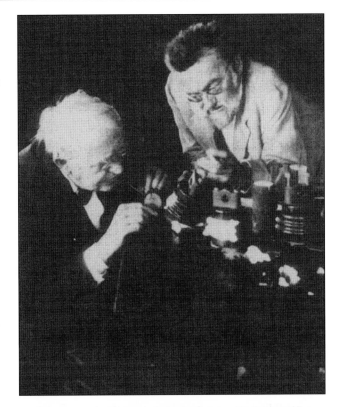

In 1922, Dr. Steinmetz demonstrated his 120,000-volt lightning generator to Thomas Edison. For his generation, Steinmetz led a new breed of scientific engineers, armed with prestigious college degrees. His studies increased the reliability of high-powered electric power transmission, which eventually eclipsed Edison's D.C. dynamo systems. Edison often expressed his admiration for Steinmetz as one of the few mathematical geniuses who never looked down on him for his own lack of training in higher math. (EFWE.)

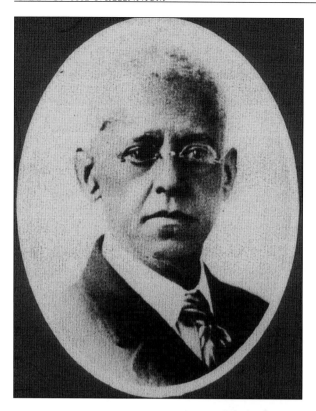

Lewis Howard Latimer (1848–1928), son of a former slave, served as the only black member of Edison's team developing the light bulb. Latimer worked with Alexander Graham Bell and Hiram Maxim (inventor of the machine gun) prior to his working on a prototype carbon filament for the light bulb. In 1882, Latimer received a patent for his process of producing carbon filaments of cotton and bamboo cellulose. In 1890, he authored a book, *Incandescent Electric Lighting*, describing his experiences with the great inventor. (EFWE.)

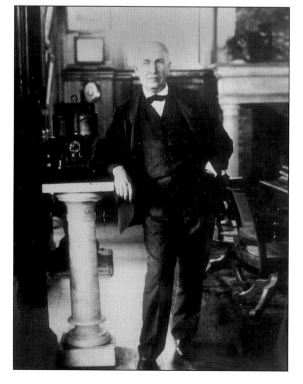

Thomas Edison is pictured here in his library complex at West Orange, New Jersey, *c.* 1910. Note his "private" chair in the background. It was not unusual for Edison to average 15 to 18 hours a day working between his laboratory and library endeavors. (EFWE.)

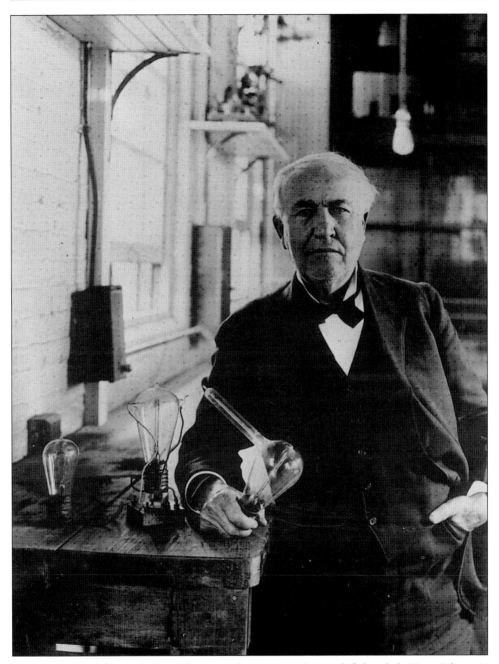

Historians still debate whether Thomas Edison was right- or left-handed. Here Edison is about 60 years old and gives no clue as to why the left hand is in the pocket and the right hand is holding the bulb. Photographs of Edison usually suggest that he was right handed. Was it possible that the great genius was actually ambidextrous? (EFWE.)

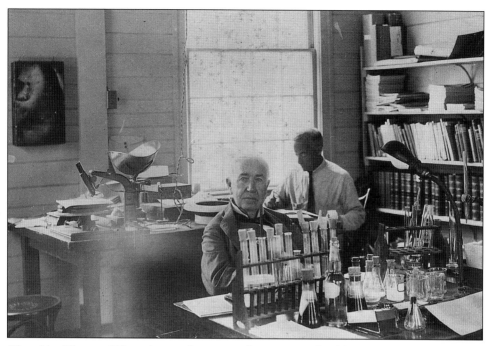

The elder Thomas Edison is seen here recording notes at his laboratory in West Orange, New Jersey. This is one of the last pictures taken at this lab, as Edison withdrew from his tedious work schedule in West Orange about 1927 because of health reasons. (ENHS.)

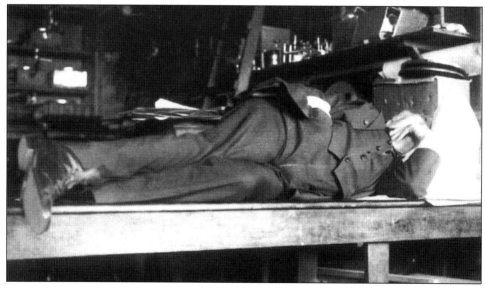

Edison's demanding work schedule left little time for sleep. In fact, Edison viewed sleep as a luxury that merely detracted from his productivity. Even so, Edison became a strong devotee of "cat naps," many of which occurred in his lab on benches or work tables. Both Mina Edison and his workers commented on the curious way that Edison sandwiched naps into his laborious work schedules. (ENHS.)

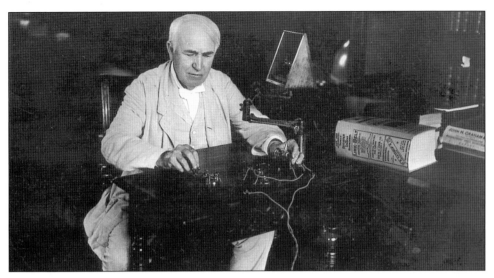

Thomas' Register of American Manufacturers, dated January 1920, lying on the desk near Edison's left hand, gives a clue to the year of this picture. It is interesting that the inventor elected to pose with his beloved telegraph system and a business directory so prominently displayed in the room. Visitors to Edison historical sites receive many lessons regarding Edison's home, garden, and laboratory activities but often obtain less information about his extensive business practices. (EFWE.)

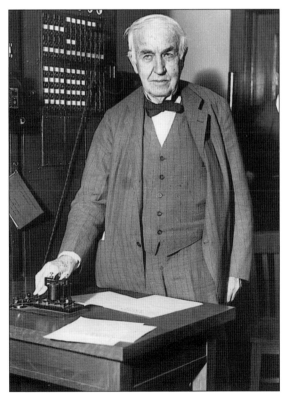

Taken in 1930, the year prior to Thomas Edison's death at age 84, this picture once again shows the great inventor's affinity for the telegraph. Although not discerned from this picture, Edison suffered from a number of serious health concerns at this time, including serious stomach problems and diabetes. (EFWE.)

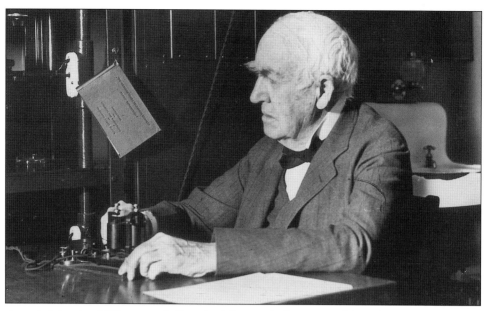

As a lad in the Midwest and Canada, Thomas Edison started his illustrious career by developing improvements on the telegraph systems of various railways. His maverick experimentation often displeased his employers and led to frequent employment moves. Although he was infatuated with all types of communications and electrical devices, the telegraph remained one of Edison's great loves throughout his life. In the year prior to his death, Edison demonstrated his timeless prowess on the telegraph key. (EFWE.)

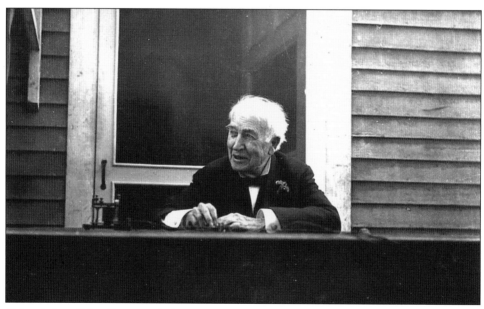

Often in later life Edison reveled in demonstrating his talents as a telegrapher. Here he is in front of his home in Fort Myers doing a demonstration for visitors, c. 1930. This is one of the last pictures of the renowned inventor at his estate. (EFWE.)

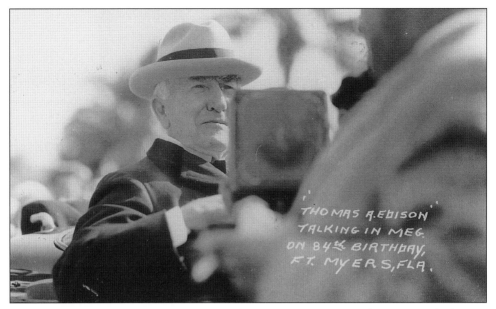

Fort Myers turned Edison's birthday on February 11 into an annual event, at which time the local press and national media had a chance to interact with "Prof. Edison." Here he communicates with the crowd through a microphone on his 84th birthday (EFWE.)

Thomas Edison spent the last 45 years of his life at his Glenmont, New Jersey home and his nearby West Orange laboratory. The estate and extensive labs and production facilities today comprise the Edison National Historic Site. Along with the Edison Estate and Museum in Fort Myers, Florida, these sites contain the largest collection of Edison materials now open to the public. Unlike the West Orange site, however, the Fort Myers Estate and Museum attract throngs of visitors throughout all seasons. (ENHS.)

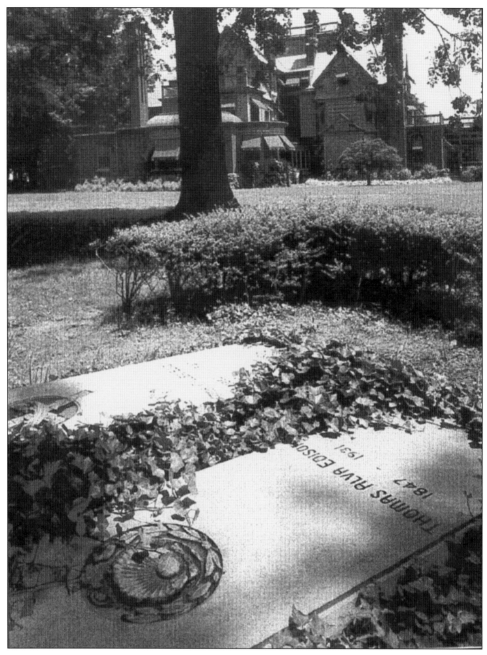

In 1963, Thomas and Mina Edison's remains were removed from their large, adjacent plots in Rosedale Cemetery and re-interred at their Glenmont estate in New Jersey. The grave markers are located in the back yard of the house. Mina's marker features religious themes while Thomas's marker displays a "pearl in an open shell," representing Thomas Edison's belief that "life units" are the essence of all human life. (ENHS.)

2. EDISON AND FLORIDA MEET

Fort Myers is the prettiest place in Florida.

—Thomas A. Edison

In retrospect, Fort Myers, Florida seemed an implausible site for the "Wizard of Electricity" to create a second home and working laboratory in the mid-1880s. Already a world-class inventor and cultural icon by this period, Edison had become accustomed not only to hard work but also to the urban amenities of the New York City area. Indeed, the New York metropolis of his era offered Edison the ideal environment for his brand of inventiveness and entrepreneurship, as well as offering him the nation's premier social milieu. How, then, did an isolated Southern village induce an acclaimed inventor and manufacturer like Thomas Edison to locate a second home and laboratory there? A partial answer is found in the background of this former military post near the mouth of the Caloosahatchee River.

Fort Myers had a rich history prior to becoming the winter retreat for America's most famous inventor. Some 400 years earlier, a native people known as the Ka-la-Lu-sa (fierce and black tattooed people, now the Calusa) inhabited southwest Florida. They maintained principal villages at Mound Key, Pine Island, and other coastal areas south of Charlotte Harbor. At the time of the first sanctioned European exploration of Florida by Ponce de Leon in 1513, the Calusa paramount chief, the "cacique," ruled over a territory of subjugated peoples covering most of south Florida. The Spanish adelantado (an official title, meaning "he who goes boldly onward") recorded that the cacique's ruling city had over 4,000 inhabitants. This powerful society exacted tribute from more than 20,000 subjects in south Florida and seldom met defeat in battle.

Ponce de Leon returned in 1521 to establish a Spanish colony in Calusa territory, from which the Spanish would scour the interior of Florida for gold and other riches (there is no basis for the legend that de Leon came to find the mythical "Fountain of Youth"). The Calusa, who feared Spanish intrusions, launched a fierce attack on the expedition, resulting in its failure and the injury of the fabled Ponce de Leon, who later succumbed to the wound in Cuba. Thus, a century before the English colonists created a form of representative

government in Virginia and the Pilgrims stepped ashore at Plymouth, Massachusetts, southwest Florida had recorded its first European-Amerindian clash of cultures. Often students of America's past overlook the fact that southwest Florida history predates other more discussed events like English colonization. Nevertheless, southwest Florida rightly lays claim to some of the first recorded history in North America.

For nearly 300 years following the death of Ponce de Leon, the Spanish ruled Florida. During that time they repeatedly failed to conquer the warlike Calusa. Most of Florida, or *La Florida* to the Europeans, fell under Spanish imperial and cultural authority during this period. The Calusa remained, however, the notable exception to Spanish imperial rule. By the mid- to late-1700s, the Calusa disappeared from their homeland—defeated not by European invaders but rather by European-borne diseases, such as smallpox and measles, and devastating wars with their neighbors. The decline of the Calusa, and whether or not there are cultural remnants of these fiercely independent people in Florida, Cuba, or elsewhere today, is a matter of conjecture. Following the demise of the Calusa, Creek Indians and escaped slaves from present-day Georgia and Alabama migrated to Florida and colonized the vacant territories. Floridians came to call these people Seminoles, or "those who go to distant places."

Southwest Florida held little significance for the Spanish and the Americans, who received Florida as a territory from Spain in 1821, until a series of conflicts (referred to as the Seminole Wars) between the federal government and Seminoles and escaped black slaves broke out in 1818. During a hiatus in 1850, between the Second (1835–1842) and Third (1855–1858) Seminole Wars, the 4th U.S. Artillery troops under the command of Brevet Maj. L.C. Ridgely established Fort Myers at the site of a former military installation. By virtue of its location 12 miles up the Caloosahatchee (river of the Calusa) from the river's confluence with the Gulf, the post could effectively control critical water access to the interior. Federal forces found the site on the Caloosahatchee strategic for the unconventional operations characteristic of Indian warfare in southern Florida.

Fort Myers ultimately emerged as a flagship military post of the Seminole Wars. Fifty-seven intact buildings and numerous amenities hosted large numbers of soldiers who served there. As the Seminole Wars unofficially ended in 1858, with the surrender of the famous Seminole military leader Billy Bowlegs at Fort Myers, the installation stood as the centerpiece of federal military activity in the south Gulf region. The federal government decommissioned the fort after the surrender of Billy Bowlegs.

As the Civil War erupted, Fort Myers remained a deserted post as the belligerents concentrated actions elsewhere in Florida and the Gulf region. The remote site of Fort Myers was little more than a rendezvous for Confederate blockade-runners and refugees until Federal troops reoccupied it late in the conflict. In early 1864, the Union command sent forces from Forts Jefferson and Taylor in the western Keys to seize Fort Myers and to convert it into the only Federal land base in south Florida.

The Union presence, eventually including African Americans of the United States Colored Troops (USCT), moved the Rebels into strengthening the Special Commissary Battalion, Florida Volunteers, known in south Florida as the Cattle Guard or Cow Cavalry. Following a number of clashes with the Union forces, some of which included soldiers of the United States Colored Troops, the Confederates decided to assault Fort Myers.

An attack on Fort Myers occurred on the morning of February 20, 1865. With the onset of nightfall, the Confederates retreated north through the piney forests and saw-grass palmettos. Confederate lieutenant Francis C.M. Boggess later described the mood of the retreat: "The whole command was demoralized." Military records in the National Archives in Washington, D.C. disclose that the Confederates sustained few casualties in that action and that the Union suffered five casualties, and that three more disappeared in action. Although not a major battle of the bloody Civil War, military experts and historical scholars maintain that Fort Myers possibly could rank as the southernmost mainland battle of the conflict, as well as the southernmost land service of Federal black troops.

The Union decommissioned the fort shortly after the battle and it remained primarily an attraction for a few hardy settlers until Maj. James Evans of Virginia surveyed and laid title to the land (some 139 acres) in 1876. Records in the county seat of Key West (Lee County was then part of Monroe County, Florida) disclose that about ten families lived in the area at that time. The cattle trade provided the major economic activity of the region, with some vegetable and subsistence farming, fishing, and a telegraph station adding to the economic base of the Fort Myers area. These activities counted for little in terms of improving the quality of life in the new town, which remained a rustic cattle and fishing village in nature until the 20th century. No electricity, lighting, ice production, gas, telephones, fire department, banks, public libraries—even by Florida standards, Fort Myers seemed rudimentary as it entered the 1880s.

By the time Thomas Edison arrived in 1885, Fort Myers had attracted its first newspaper and had grown to a population of 50 families. That same year community leaders incorporated the town in order to receive much-needed state assistance for improvement projects. In the following two years the town became the seat of newly established Lee County, and it witnessed the rise of its first major tourist draw, the stately Royal Palm Hotel. Despite these relative advancements, Fort Myers remained primarily a "town of cow trails" and parochial local folk until the advent of the railroad and "modernization" in 1904.

Thus, the Fort Myers that greeted the urbane "Wizard of Electricity" in the 1880s represented a huge leap in distance and culture from the New York City area, which proved such a suitable environment for Mr. Edison. Even so, the tropical flora and fauna and isolation of the town might have been the very factors that lead Edison to establish a winter estate there. Whatever the reasons, Thomas Edison and family and friends would play a large part in the transformation of Fort Myers to the complex urban area it is today.

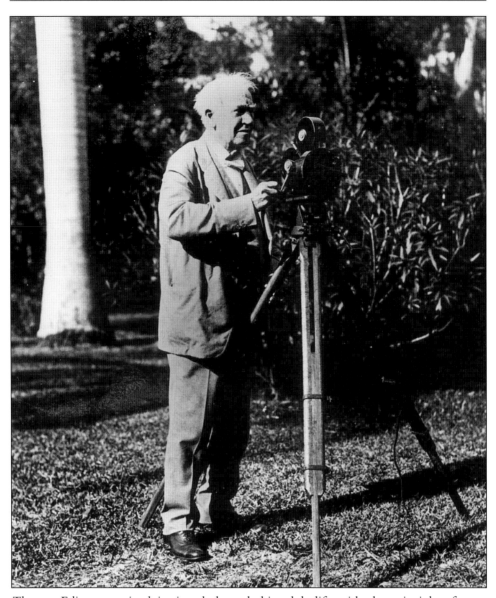

Thomas Edison remained intrigued through his adult life with the principle of mass communication. The phonograph and the motion picture discoveries and improvements represent perhaps the two best examples of his original work and infatuation in this area. Edison's preoccupation with a camera that could produce motion pictures consumed a good part of his energy during his visits to Fort Myers, Florida from 1914 onward. In this picture, Edison demonstrates the latest development (note the crank handle for power) in the motion picture camera in the botanical gardens of his winter estate in Florida. Although Edison pioneered the theory of motion pictures, he created and updated new practical versions of the device from other advancements. Visitors to the Edison-Ford Winter Estates Museum see extensive displays there of Edison's most important developments regarding moving pictures. (EFWE.)

At the time of the first recorded European contact with southwest Florida in 1513, the region fell under control of the fierce Calusa Indians. From the 16th to the 18th centuries, the Spanish failed to subdue the Calusa "caciques" (rulers) and their 60 towns and vast territory. Eventually European diseases and raids by hostile Indians decimated the Calusa, and by the 1760s when Spain ceded Florida to England, the few remaining Calusa dispersed throughout Florida or departed for Spanish Cuba. (Map courtesy of Lindsey Wilger Williams in his *Boldly Onward*.)

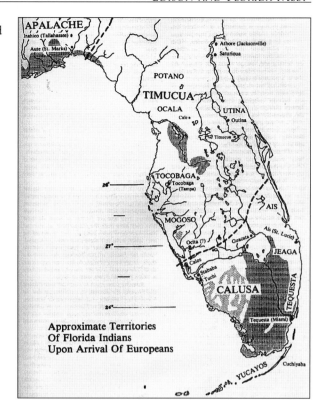

Approximate Territories
Of Florida Indians
Upon Arrival Of Europeans

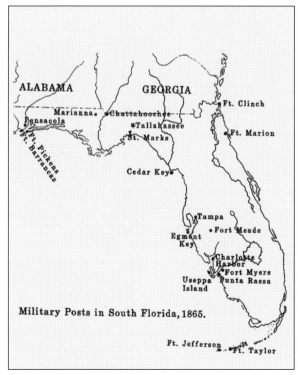

Military Posts in South Florida, 1865.

Military records in the National Archives in Washington, D.C. disclose that the conflict between the Union and the Confederates at Fort Myers on February 20, 1865 resulted in few Confederate casualties and five Union casualties (all black soldiers), as well as three missing in action (all black soldiers). (Author's map.)

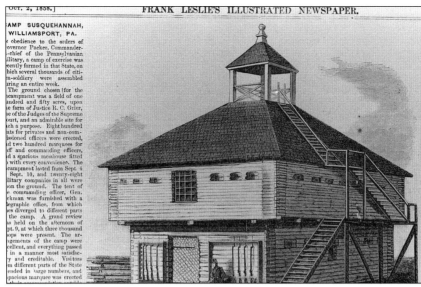

The Seminole Indian Wars federal installation of Fort Myers stood on roughly 139 acres on the south bank of the Caloosahatchee River. The compound replaced the former Fort Harvie, which had gained prominence during the Seminole campaigns from 1841 to 1842. In its brief history, Fort Myers gained distinction as one of the principal posts in the campaigns to subdue and remove the Native Americans from south Florida. The fort gained such notoriety that *Frank Leslie's Illustrated Newspaper* published a picture and story on the post and its famous Blockhouse in its October 2, 1858 issue.

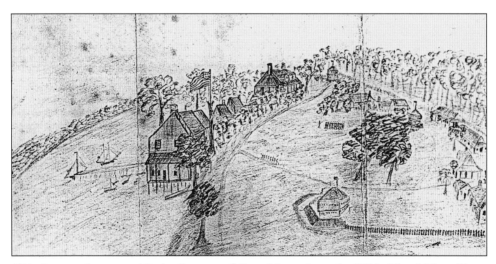

This is an unknown soldier's diagram of Fort Myers in early 1864. The U.S. military abandoned the post at the end of the third phase of the Seminole Wars in May 1858, and the Union moved boldly to reactivate it as a Federal installation on January 7, 1864, during the Civil War. This picture and the military records relevant to the reactivation of the fort in 1864 are found in the Department of the Gulf, Letters Received, Record Group 393, National Archives, Washington, D.C.

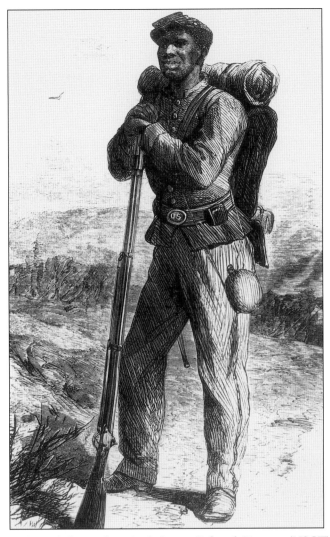

Companies D and I of the 2nd United States Colored Troops (USCT) moved from Key West to Fort Myers in April 1864. The commander of Fort Myers requested new troops to strengthen the post's defense and to enhance his ability to interdict the Confederates' south Florida cattle trade. During the Battle of Fort Myers on February 20, 1865, the black troops provided valuable service to the Union. The first regiment of the USCT mustered into Federal service in June 1863, at Washington, D.C. Some of the enlistees numbered free blacks from the North, but most represented former slaves enlisted as "freedmen," "contraband," or "farmers." Former slaves eventually comprised three-fifths of USCT servicemen. As early as October 31, 1863, one of the Bureau's commanders wrote Secretary of War Edwin Stanton that the "colored troops have already established for themselves a commendable reputation . . . [for] their discipline, their endurance, and their valor." Pictured here is a former slave serving in the USCT in the American Civil War. (Courtesy of the Schomburg Center for Research in Black Culture, New York Public Library.)

During the Battle of Fort Myers on February 20, 1865, former slave John Wallace, then serving in the USCT, received serious head wounds. Following the war, Wallace served in the Florida legislature and gained fame as the presumed author of *Carpetbag Rule in Florida*. (Courtesy of Florida Department of States, Division of Library and Information Services, Florida State Archives, Tallahassee, Florida.)

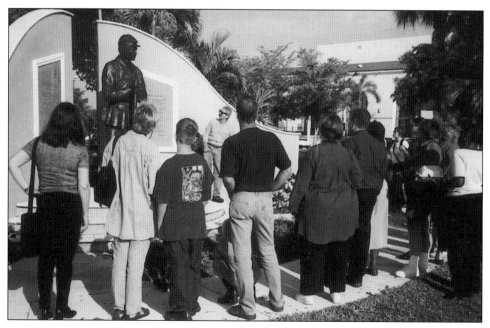

On Veterans' Day 1998, the City of Fort Myers dedicated this eight-foot, $78,000 monument to the service of the black troops at Fort Myers during the Civil War. Here, a local speaker describes the monument's background to a group of tourists. The memorial to the USCT is perhaps the southernmost monument to blacks in the federal service.

At the time of Edison's first visit to Fort Myers in 1885, southwest Florida was a rugged frontier with few pockets of settlement. Composed mainly of Gulf coast beaches and waterways and interior wetlands, palmetto thickets, and saw grass hammocks, southwest Florida must have seemed like a scene from the pre-historic past to an urbane Northeasterner like Edison. This picture represents a scene from what interior southwest Florida might have looked like only steps from the hamlet of Fort Myers in the mid-1880s. (Courtesy of the Tebeau-Field Library of Florida History.)

The Sloop Ada.

Shallow-draft boats, such as the *Ada* pictured here, provided the fastest and most efficient means of plying the Caloosahatchee River in the late 19th and early 20th centuries. Although steamers and the railroad in 1904 eventually replaced these boats, they did prove useful for decades in transporting goods and people from the Gulf to points inland, such as Fort Myers. Early photographers of Fort Myers waterfront show a busy river port accommodating numerous ships of this sort. (COLF.)

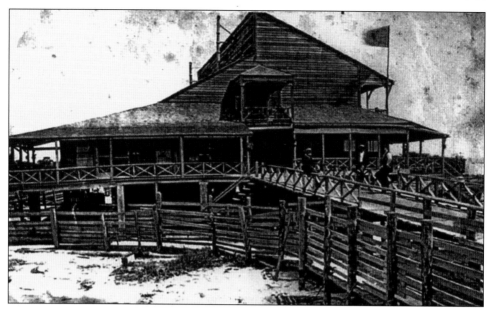

Mr. and Mrs. Schultz arrived in Punta Rassa in 1867, when the International Ocean Cable Company appointed George Schultz manager of the important local relay station. They converted the former Civil War barracks into a "cattlemen's hotel." Later, it became the famous Tarpon House. Reportedly, the first news of the sinking of the battleship *Maine* in Havana harbor reached the mainland United States on February 15, 1898 at the Punta Rassa terminus of the underwater cable line to Cuba. (FMHM.)

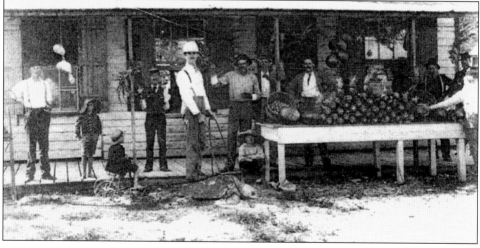

In 1886, the Edisons' domestic servants might have shopped for food and other sundry items at Blount's General Store, located on the northwest corner of First and Hendry Streets. Jehu Blount and his wife, Mary Jane Hendry, relocated to Fort Myers in the 1870s. (Her relative Capt. F.A. Hendry is often termed the "Father of Fort Myers.") This "Fort Myers' mall of the past" dispensed a cornucopia of items of the time, including the latest rumors for the "boys" of Fort Myers. (FMHM.)

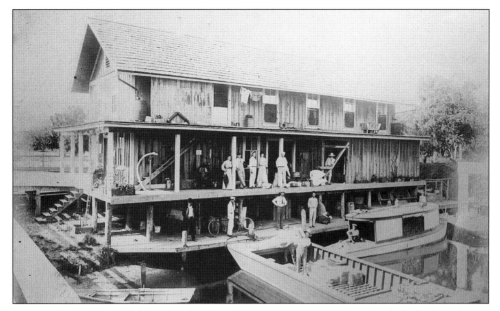

Prior to the coming of the railroad in 1904, water transportation primarily linked southwest Florida to the outside world. Waterways also provided the lifeblood of regional transportation and commerce, as in this riverfront scene from 1900. This boathouse, built and run by a settlement of Koreshan communitarians in Estero, Florida, near Fort Myers, served as a river port, boat repair facility, mail depot, and general store all in one. (COLF.)

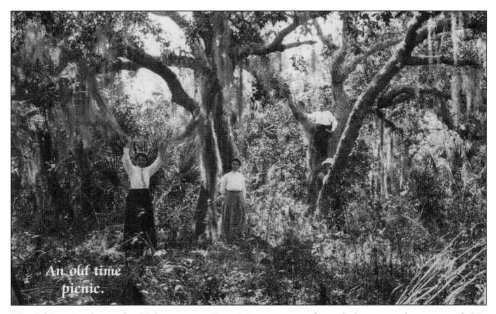

Picnicking in the early 20th century Fort Myers area reflected the rugged aspects of this region of Florida, what Thomas Edison termed a "jungle." Apart from Fort Myers proper, isolation characterized most of Lee County until the mini-building boom of the 1920s. The Edisons certainly helped break down that isolation by their very presence. (COLF.)

A devil ray (manta ray) fishing boat captain collects fuel for the impending voyage in southwest Florida in the early 20th century. Note the lush tropical flora of the region in this era. Devil ray fishing drew many Northerners to the Fort Myers area in the early 20th century. (TFL.)

In 1917, former President Teddy Roosevelt tried his hand at capturing devilfish and gopher tortoises in the wild country of southwest Florida. Later, he wrote of his adventures in *Scribner's* magazine and *The American Museum Journal*. In the *Scribner's* article, Roosevelt captured the feelings of Thomas Edison and countless other winter visitors to Fort Myers: "We had beautiful weather . . . the sunsets were wonderful, across the Mexican Gulf . . . while the soft, warm night air was radiant in the moonlight."

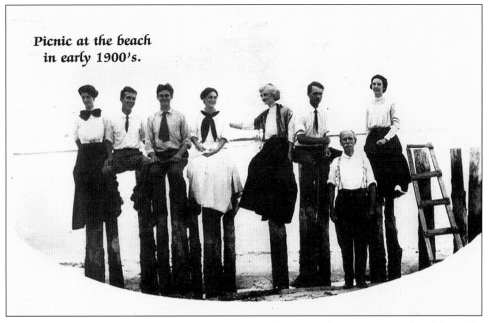

Picnic at the beach in early 1900's.

The trip from Fort Myers to the beach took many hours on the primitive roads of the early 20th century. This group represents a common sight at the beach on any given Sunday. Note the formal attire, worn until Fort Myers Beach became a tourist Mecca in the 1950s. Today, the Town of Fort Myers Beach is just minutes away from Fort Myers by car and is as a playground for hundreds of thousands of American and foreign tourists. (COLF.)

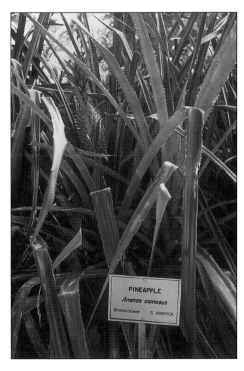

Thomas Edison's wide-ranging interests in botanical gardens and experiments prompted him to raise or attempt to raise hundreds of domestic and imported plant species at his Florida home. This South American pineapple now growing in the Edison–Ford Winter Estates' gardens represents one of 430 species of plants, trees, and shrubs that can still be seen at Edison's former winter home. In the early years of incorporation, the Town of Fort Myers adopted a blooming pineapple on its town seal. (EFWE.)

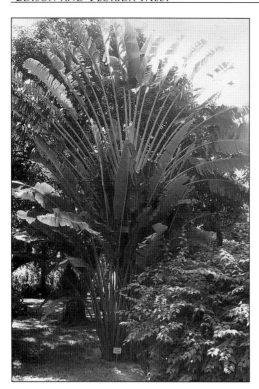

A Traveler palm grows in the Edison botanical gardens. Hundreds of thousands of tourists gaze upon this today and are reminded of Thomas Edison's special interest in tropical plants and gardening, which so attracted him to rugged southwest Florida. (EFWE.)

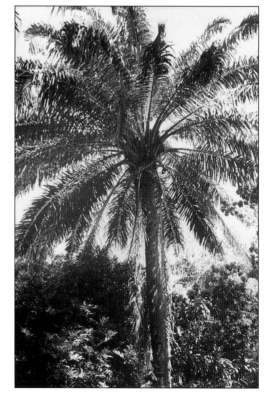

This African oil palm, located in the Edison-Ford Winter Estates garden, is an example of one of the many tropical trees that interested Thomas Edison. This palm and many others similar to it can be seen in the garden that Edison himself first designed in the mid–1880s. (EFWE.)

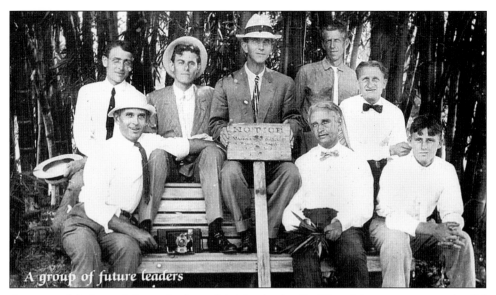

A group of designated future leaders of the "early days" of Fort Myers presents a splendid image here. Note the giant bamboo so peculiar to the region in the background. This canebreak bamboo remains a feature of the Fort Myers area, unlike these "future leaders" who seemed to have disappeared from the pages of history. (COLF.)

In 1897 Fort Myers, with a population of roughly 900 permanent residents, received its first "modern" store, courtesy of businessman Harvey E. Heitman. The state-of-the-art brick building opened for business at First and Jackson Streets and evolved into one of the premier stores of the region. When the Edisons purchased local goods, Harvey Heitman's store might have provided the items, including groceries and local produce. (FMHM.)

49

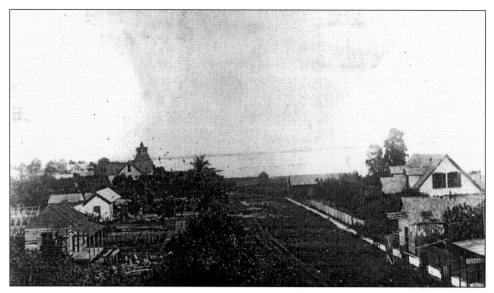

Until the arrival of the railroad to Fort Myers in 1904, most streets remained unimproved thoroughfares, located primarily in the business district. This picture of Hendry Street in 1898 portrays such a scene. Note the absence of sidewalks, which were later made of shell, as were the "improved" streets following the introduction of the railroad and "horseless carriages" in Fort Myers in the early 20th century. (FMHM.)

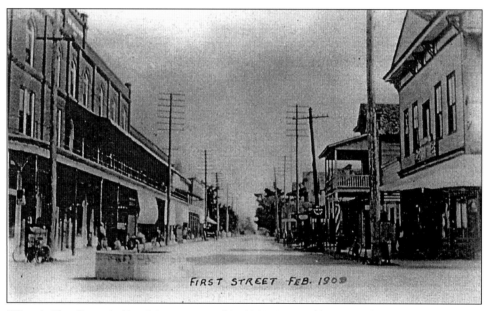

Historic First Street in Fort Myers appeared in 1909. Situated between the waterfront and the town proper, First Street and its environs hosted such historical attractions as the Key Stone Hotel, Riverview Hotel, Hendry House, and the Fort Myers, or Royal Palm, Hotel, which wooed Northern "gentlemen" with a toilet and bath on each floor. Note the absence of cars and the presence of a watering trough for horses. (EFWE.)

One of the area's first cars.

By 1910, this type of "devil wagon" could be seen on the streets of Fort Myers, or what then passed for streets. The predominant cattlemen of Fort Myers saw the first automobiles as noisy, stinky cattle agitators, and other local residents deemed the breakneck speed of 15 miles per hour as simply too fast for their sand- or shell-packed "roads" (mostly expanded cattle trails at this time). (COLF.)

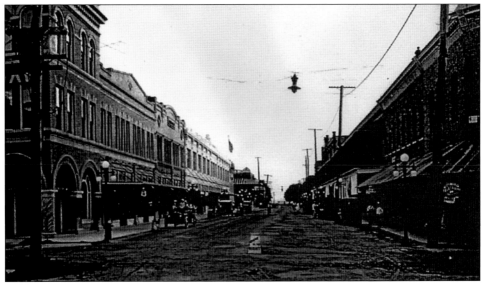

As Fort Myers matured in the early 20th century, its way of life transformed from rural cow town to modernizing tourist Mecca. This scene of First Street and its business district, c. 1915, discloses such "modern" conveniences as the horseless carriage and electric lighting. Even so, the roughshod streets and shell-packed sidewalks belie a city begging for public works improvements. (FMHM.)

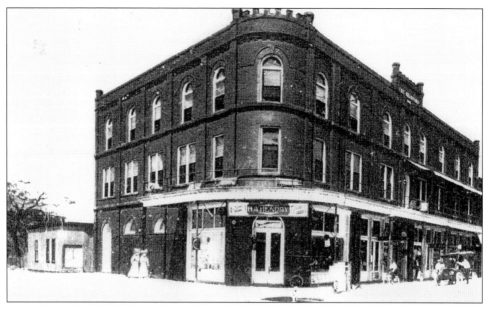

With the arrival of the railroad in 1904, Fort Myers underwent a building boom. About this time, Tootie McGregor (widow of oil baron Ambrose McGregor) extended financing to Harvey Heitman for construction of the lavish Bradford Hotel (seen here in 1910) named in honor of Tootie's son, Bradford McGregor, who had died in 1902. Situated in the heart of the business district, The Bradford attracted local travelers, sports fishermen, and Northern winter tourists to its second- and third-floor sleeping rooms. (FMHM.)

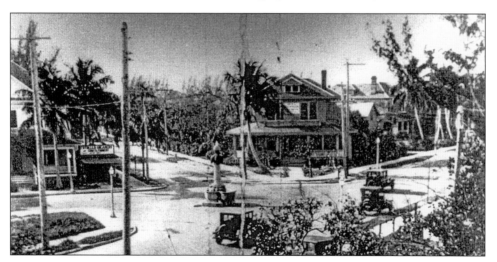

This "bustling" scene of early Fort Myers depicts one of the city's busiest hubs in the early 20th century. This intersection marked the confluence of Main Street, Anderson Avenue (now Martin Luther King Boulevard), Cleveland Avenue (also known as the Tamiami Trail), McGregor Boulevard (formerly Riverside Avenue), and Carson Street, with the McGregor Monument (erected in 1913 but later moved to other locations) overseeing all activity of this center of historical Fort Myers, Florida. (EFWE.)

The Caloosahatchee riverfront at the time of Edison's first visit in 1885 must have looked like a foreign world to the renowned inventor, who hailed from the Midwest and later lived in New England and the New York City area. This postcard scene of riverfront just east of Fort Myers depicts the tropical nature of southwest Florida in Edison's era. One can easily imagine why Edison referred to his winter estate in Fort Myers as his "jungle."

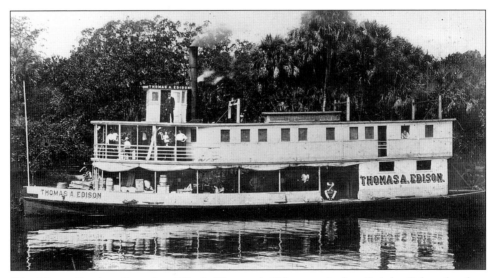

The Menge Brothers Steamboat Line's *Thomas A. Edison* routinely sailed the Caloosahatchee River. The Edison family often rode the *Thomas A. Edison* on sightseeing tours, sometimes as far upriver as Lake Okeechobee. Captains Fred and Conrad Menge used the ship beginning in 1902 as a multi-purpose river steamer in the days when the lack of highways made truck and automobile travel a near impossibility in the regions east of Fort Myers. A major fire destroyed the ship and many nearby buildings in 1914. (EFWE.)

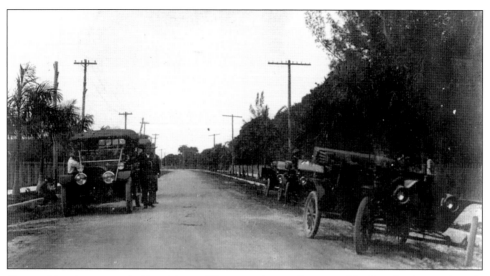

During his winter stays in Fort Myers, Thomas Edison often assembled his family and friends in a traveling caravan for local sightseeing ventures. In this *c.* 1912 picture, Edison and friends appear to be gathering for such a trip on McGregor Boulevard (formerly Riverside Drive). Edison and company introduced some of the first Ford automobiles, the Model-Ts, to southwest Florida (EFWE.)

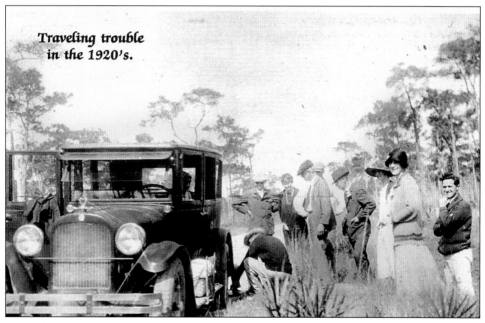

This photograph from the 1920s shows a common occurrence on the roads of southwest Florida: tires that could not withstand the tortures of unimproved roads. The Edison family and friends often recorded the same kinds of tire problems during their traditional daytime sightseeing and longer overnight camping trips in Lee County and to the Everglades (COLF.)

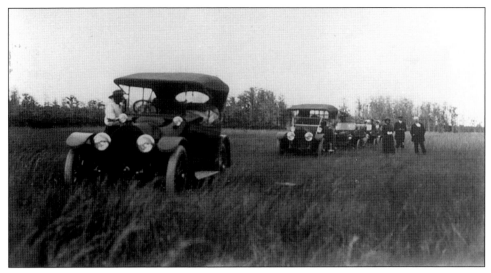

Edison and entourage are on one of his much-publicized camping trips in southwest Florida. Note the contrast between one of Edison's camping trips and the typical camping trip of today. The group is using a Ford Model-T and possibly a modified Model-T with top down in the rear of the column as a chuck wagon. Edison's vintage vehicles can now be seen in the Edison-Ford Winter Estates Museum in Fort Myers, Florida. (EFWE.)

Although seldom separated from Edison during their visits to Fort Myers, here John Burroughs and Henry Ford enjoy a ride in one of Ford's Model-T automobiles, c. 1914. This model contains the acetylene lamps which gave way to Ford's innovative electric lamp in 1915. Once again the presence of a spare tire betrays the passengers' fear of road problems on the rugged thoroughfares of early 20th-century southwest Florida. (EFWE.)

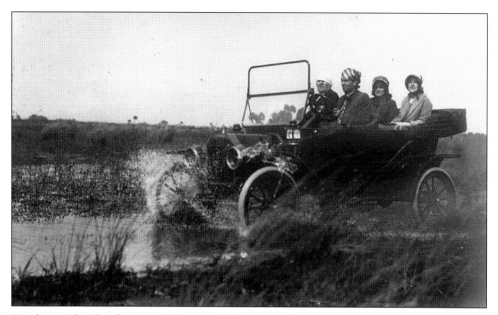

Southwest Florida often provided unusual adventures for the Edisons on their camping trips. Here the Edisons "get back to nature" Everglades style. Obviously, Thomas Edison had the confidence to take his "humble" Model-T into the knee-high standing water of the Everglades. Note Edison's bandaged head. He was known to have numerous ear infections, which contributed to his hearing loss. (EFWE.)

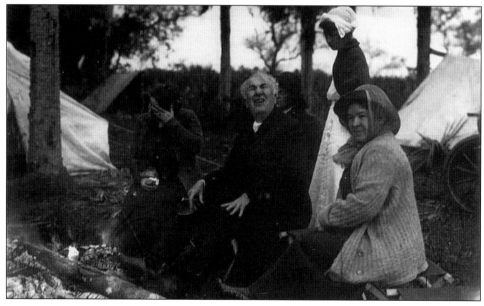

"Smoke gets in your eyes." Thomas Edison appears to be reacting to the campfire's smoke during one of his many camping trips in southwest Florida. Note the formal attire—always a hallmark of Edison's camping trips—and the maid in the background who is assisting the back-to-nature campers, c. 1918. (EFWE.)

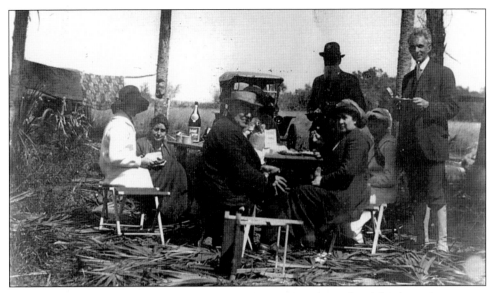

In a classic pose, Thomas Edison, John Burroughs, and Henry Ford and families enjoy a camp side luncheon among the cabbage palms of southwest Florida, *c.* 1915. As always, a Model-T Ford automobile accompanied the not-so-casually dressed "outdoors men." The folding chairs must have helped the "city slickers" adapt to the rigors of camping. (EFWE.)

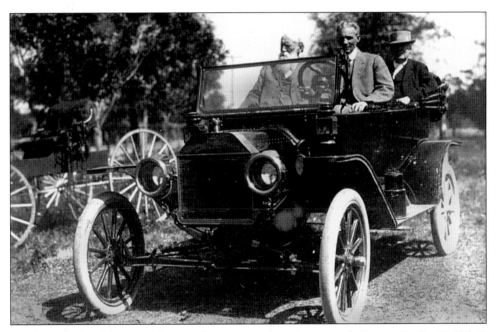

Southwest Florida's most famous threesome poses in one of Henry Ford's Model-T automobiles, *c.* 1914. Edison, Ford, and Burroughs first met at Edison's behest in Fort Myers in 1914 and continued their winter reunions there for a number of years. Folklore recounts many meetings between them and townsfolk in such circumstances; the stories of these have been passed down through the generations. (EFWE.)

57

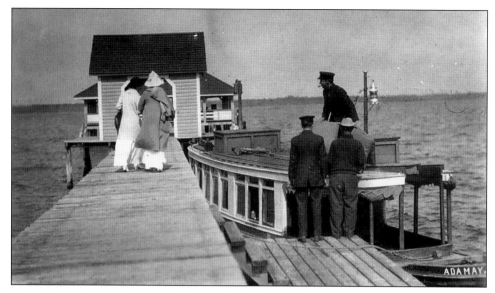

The *Adamay* ties up at the Edison dock in the early 20th century. It is said that Edison and his family held dances and socials in the gazebo at the end of the dock. Similar stories have Edison fishing without bait at the end of the dock. Apparently the inventor found the dock a place of welcomed solitude, with or without the benefit of catching fish. (EFWE.)

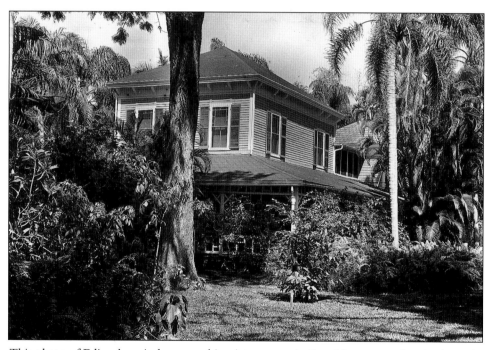

This photo of Edison's main home on his winter estate in Fort Myers was taken in the early 1900s. To the right can be seen the guest house, which Edison in 1907 turned into additional private quarters, servants' quarters, and the main kitchen for his Fort Myers retreat. The two houses are connected by a vine-covered walkway. (EFWE.)

3. Edison and His "Florida Eden"

It [Fort Myers] *is looking better today than ever and I have made up my mind that I will not let a year go by without coming to it.*

—Thomas A. Edison

When Thomas Edison arrived in Fort Myers, Florida in March 1885, he most likely planned on assessing its giant bamboo as a possible replacement filament for his incandescent light, as well as observing exotic flora and fauna in the wild, tropical country of southwest Florida. In a mere 24 hours, the world-renowned inventor had become so enthralled with the quaint village on the Caloosahatchee River that he made the bold—and perhaps impulsive—decision to purchase land in Fort Myers on which to create his "Florida Eden." From this humble beginning, Edison's purchase and subsequent winter retreat have now become one of the major historical site attractions in the United States. Though Edison's life is replete with interesting lessons and anecdotes, certainly the birth and evolution of his winter estate in Fort Myers rates as one of the more intriguing aspects of his storied life.

Throughout his adult years, Thomas Edison impressed friend and foe alike as a person of determination and quick temperament. And so it was with Edison's decision to buy the 13-acre Summerlin parcel in Fort Myers barely one day after arriving at the hamlet. Although Edison initially offered $3,000 for the property, upon return to New Jersey in 1885, he shrewdly negotiated the price down to $2,750. Edison's records suggest that he planned on using the "old Summerlin place" to establish winter homes for him and friend Ezra Gilliland and for extensive personal botanical gardens. His plans during the first three years of completing what would become Seminole Lodge also evolved to the point at which he considered undertaking serious experiments in his new Fort Myers laboratory and in his ever-expanding botanical gardens. From the inception of Seminole Lodge, Thomas Edison desired it to be both a winter retreat from the frenetic life of the New York City area and a fertile ground for new experiments.

Although most frequently remembered as a great inventor, Thomas Edison represented one of the era's true Renaissance men, a person interested in a broad spectrum of work and

pioneering ideas. It is not difficult for visitors to the Edison-Ford Winter Estates to envision the energetic inventor's plans for his winter retreat and the priorities of his life as they view what Thomas Edison so carefully planned and completed under his own guiding hand. The Edison Estate stands even today as a monument to the unique mentality and drive of the "Wizard of Menlo Park."

Edison and Gilliland agreed to jointly acquire the property and develop two homes on it, but that agreement soon unraveled under pressure of a serious financial dispute between them. The materials for the planned homes for Edison and Gilliland and Edison's first laboratory were to be shipped from Boston by the Kennebec Framing Company and the S.A. Nye Co. of Fairfield, Maine. Experts and amateur historians alike claim that Edison's plans called for an early prefabrication design, but shipping records do not substantiate this. As in most aspects of work and private life, Thomas Edison himself created the detailed designs for the structures and interiors.

Edison commissioned local agents, namely Huelsenkamp and Cranford, to complete the sale of the land and the construction of the first building on it according to his directions. In a letter to Huelsenkamp and Cranford of Fort Myers, Florida of October 23, 1885, Edison wrote from New York: "Gents: please have prepared at once a map drawn to scale, of my lots, showing everything that will be necessary to have in order to locate [my] buildings [and] the laboratory." Edison went on to explain in the letter that he would direct "fully" the design and construction of the building and botanical gardens through his handpicked agent from the North, Eli Thompson.

Thompson performed his duties well, overseeing the layout and completion of Edison's plans. Per the "Wizard's" directions, Thompson expedited the construction of the two-story residences and a laboratory building (with Thomas Edison's father's assistance) and ordered the renovation of an existing old house, now known as the "Caretaker's Cottage," (perhaps the oldest standing building in Fort Myers), and the construction of a pier into the Caloosahatchee River. Once these structures were completed, Edison sent further instructions to Thompson regarding extensive improvements of them in preparation for his impending visit.

Locals watched in awe as the new Edison winter estate took form and talked much among themselves about the improvements and how they would "modernize" Fort Myers. Now that the world-famous inventor had imbued his embryonic estate with the latest ingenuity and technology, surely it would only be a short time until Fort Myers shared in these improvements and related advancements, such as electric lights and street railways. The citizens of Fort Myers rejoiced in this belief that Edison would bring the modern world to them, even if these improvements would "keep the cattle awake."

Thomas Edison's ledger and accounts journal for the years 1885–1887 disclose much about his plans for completing and furnishing his property and his plans for Fort Myers itself. Edison's ledger contained 224 pages relating to his plans for the estate, and his accompanying journal continued another 240 pages on the same subject. Judging by the purchasing power of the 19th-century dollar, Edison paid handsomely for the house, laboratory, furnishings, and labor on his estate (although Gilliland initially shared some of the expenses); Edison rendered a total of $10,254.35 for the two houses (both of which underwent major renovation in 1907–1908), laboratory, boat charter, and marine insurance, and in 1886 alone he paid his

workers $1,874.22. Indeed, Thomas Edison had a grand plan for his evolving winter estate in Fort Myers, Florida.

It must have seemed to the town folk of Fort Myers in the mid–1880s that Edison would spare no costs to create his winter estate. In addition to the buildings on the property, Edison also impressed the residents of Fort Myers with the extensive botanical gardens he had ordered. Edison's notes disclose that he realized quickly on his first trip that plants would grow well near the warm river water of the Caloosahatchee. His design thus called for extensive botanical gardens for the area adjacent to the river and for many of the trees, plants, and shrubs to be imported from around the world. In his Fort Myers laboratory, Edison originally experimented with canebreak bamboo, but he subsequently ordered and had planted dozens of exotic species, such as African sausage trees, Indian cliff date palms, South American sloth trees, Japanese azaleas, Hawaiian plumerias, Chinese sweet oranges, and other innumerable citrus and mango trees, bromeliads, orchids, spice trees, and varieties of the towering giant bamboo that reached 60 feet tall and sprouted up to 12 inches overnight in the summer rainy season.

Today, visitors to Edison's grand winter estate see not merely the gardens and buildings he created in Fort Myers but also the range of history made by him in this major urban area that once so eagerly embraced the "Wizard of Menlo Park."

In September 1885, Thomas Edison's Fort Myers agents, Huelsenkamp and Cranford, sent him a telegram requesting "prompt" action on the payment for the Summerlin place. Whether Edison delayed in payment because he sought to negotiate a lower price for the property or simply had second thoughts about buying land in Florida remains a mystery. In any event, the 90-day closing date passed and Edison orchestrated a later closing at a reduced price for what would become his winter estate in Fort Myers. (EFWE.)

Most accounts of Thomas Edison's purchase of property in Fort Myers, Florida, state that he paid $3,000 for the Summerlin place in 1885. In fact, as this historical letter indicates, Edison had negotiated down the initial offer of $3,000 to $2,750 for his proposed winter estate. Associated documents at the Edison-Ford Winter Estates disclose a very shrewd businessman as well as extraordinary inventor in the person of Thomas Edison. (EFWE.)

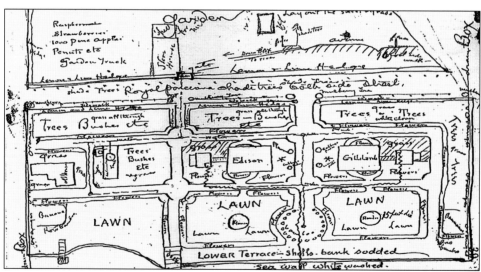

Dated April 5, 1886, Edison's sketch of the property he purchased in Fort Myers discloses his long-term development plans. His estate would include comfortable houses for him and his friend Ezra Gilliland and would reflect the tropical characteristics of southwest Florida. From the sea wall in the west to the large garden in the east, the estate would be replete with wide lawns, trees, bushes, and copious tropical fruit trees and plants. (EFWE.)

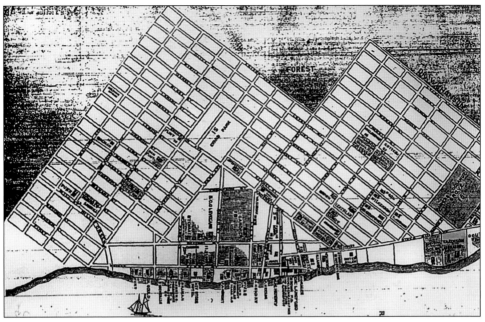

Even though Fort Myers was a rustic hamlet at the time of Edison's arrival in 1885, this map from that year shows a strong sense of civic involvement and orderliness in the town's layout. Note the orderly configuration of the early "cow-town" of Fort Myers and its developed waterfront. Edison's property, the former Summerlin place, is depicted by the shaded boxes in the far southwest section of this diagram. (EFWE.)

In this letter, Thomas Edison acts as agent for Ezra Gilliland and himself regarding payment for materials the two ordered for their proposed winter homes in Fort Myers in late 1885. The total payment of $1,150, drawn upon the Bank of the Metropolis in New York, was to be paid upon safe delivery of the cargo to Punta Rassa. The authorization letter carries the distinct signature of T.A. Edison. (EFWE.)

63

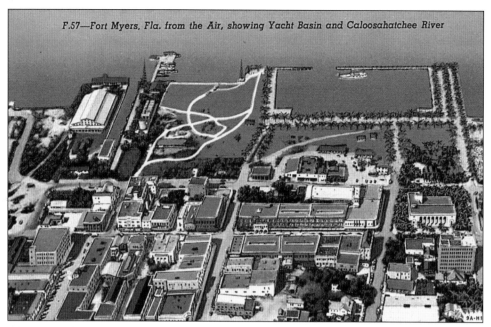

F.57—Fort Myers, Fla. from the Air, showing Yacht Basin and Caloosahatchee River

The City of Fort Myers underwent unprecedented growth in the 1920s, with the official census figures showing a growth from 3,678 in 1920 to 9,082 in 1930. Even though the collapse of the boom years in 1925 and 1926 dramatically reduced the growth rate of this region, Fort Myers continued to benefit from the steady winter tourist season of affluent Northerners like Thomas Edison throughout the late 1920s and into the 1930s. The postcard gives a good perspective of the downtown area of Fort Myers in the late 1920s.

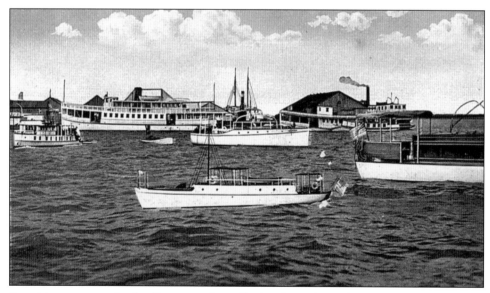

Fort Myers possessed a bustling waterfront district along the Caloosahatchee River in the 1920s. The scene in this postcard may have marked the first point of disembarkation for prosperous Northern visitors like Thomas Edison and his family in the 1920s.

Thomas and Mina Edison enjoy one of their frequent fishing getaways on the Caloosahatchee River in Fort Myers, Florida, in the 1920s. The oarsman is possibly an Edison estates worker. (EFWE.)

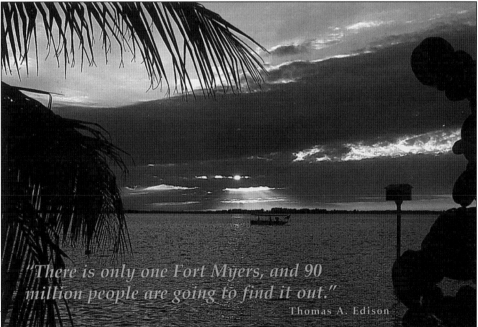

"There is only one Fort Myers, and 90 million people are going to find it out."
— Thomas A. Edison

This serene scene from the 1920s pictures the Edisons in their battery-powered electric launch, *Reliance*, enjoying the magnificent sunset on the Caloosahatchee River in Fort Myers, Florida. Superimposed over the idyllic setting is Thomas Edison's famous statement about the city that hosted him for so many winter seasons. (EFWE.)

In 1917, former Rough Rider and President Teddy Roosevelt traveled to southwest Florida for "a month's work with the harpoon and lance." His plan was to use these instruments to capture a record-breaking devilfish in the waters off Captiva Island near Fort Myers. Roosevelt killed one that reached a staggering breadth of 16 feet, 8 inches, while the crew of his chartered boat urged him on with a chorus of "Iron him, colonel." (Courtesy of *Scribner's* magazine, September 1917.)

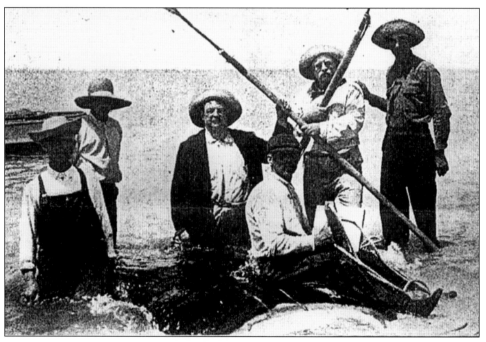

Roosevelt and crew of the harpooning boat exhibited their kill on a Gulf beach near Fort Myers. Roosevelt recorded that his struggle with this "monster" lasted 26 minutes and covered over two miles of surf. It appears that this is the devilfish Colonel Roosevelt measured and noted at 16 feet, 8 inches in breadth, a mere 2 feet in breadth smaller than the acknowledged record of the era. (Courtesy of *Scribner's* magazine.)

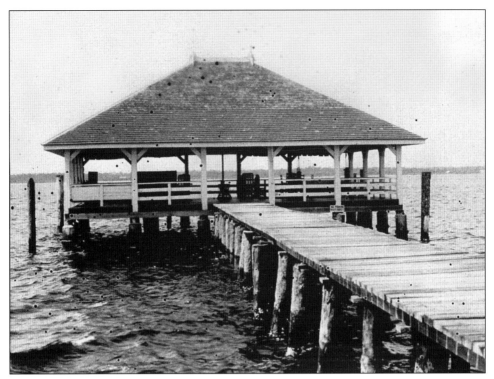

Edison's initial plans for the Summerlin property after he purchased it in 1885 included a 357-foot wharf, later expanded in 1918 to a more sturdy 1,500-foot dock into the Caloosahatchee River. Today, guides at the Edison-Ford Winter Estates tell tourists about Edison's quirk of fishing off the dock without baiting his hook. The reason for this—while on the dock, Thomas Edison was not after fish but rather solitude. (EFWE.)

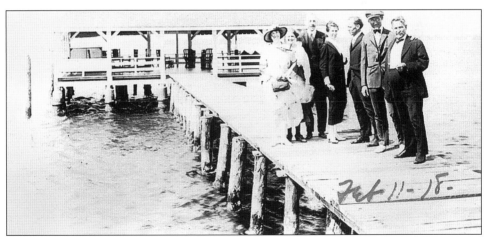

Visitors to the Edison winter estate appear to be waiting for their illustrious hosts, the Edisons, to join them on the pier on this balmy February afternoon in 1918. The Edisons often used the specially built pier for social events during their winter stays in Fort Myers. Note the seating and viewing area in the pavilion at the end of the structure. (EFWE.)

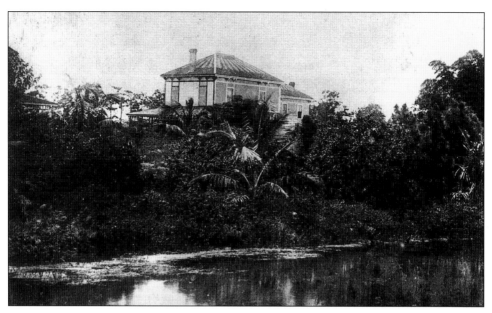

Pictured here is the winter home and associated guest house of Thomas Edison and family at their Fort Myers "Eden" in the early 1900s. Edison's workers completed renovation of the guest house from 1907 to 1909, after which the Edisons used the structure for both family meals and guest quarters. Additionally, Mina Miller Edison used the facility as a "domestic retreat" and private office. (EFWE.)

The Edison winter home in Fort Myers is viewed from the street side, at first Riverside Avenue and later McGregor Boulevard. Edison's penchant for tropical plants and wide verandas is apparent in this early 1930s scene. (EFWE.)

Of the eight buildings of historic interest on the Edison estate in Fort Myers, the main house is considered the most significant site. Built in the mid-1880s, the house remained intact until 1907, when it underwent remodeling, including the addition of wide porches to enhance the wind flow through the house. This picture, *c.* 1910, gives a particularly good view of part of Seminole Lodge and Edison's tropical botanical garden. (EFWE.)

In a classic pose of the beloved couple, Mina Edison shields her husband from the sun during an outing in southwest Florida in the mid-1920s. Although Thomas Edison reportedly despised exercise, he and Mina often took walks to enjoy the flora and fauna of Fort Myers. Given the presence of folding stools, it appears that the Edisons might have been bird watching on this sunny winter day in southwest Florida. (EFWE.)

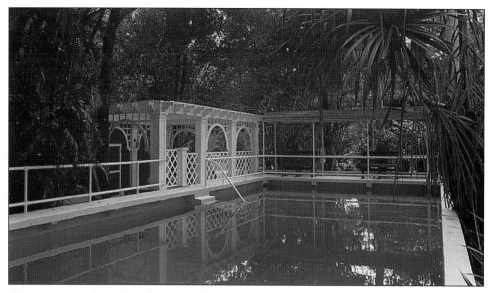

Contrary to myth, Edison did not eschew using his pool in Fort Myers, but rather dipped in it periodically. Records indicate that Edison used his own Portland Cement to construct the pool in 1910. Later engineers used the same type of Portland Cement to complete Yankee Stadium in New York City in the early 1920s. Edison's pool holds a special place in history as one of the "first, grand pools" of Florida's affluent snowbirds. (EFWE.)

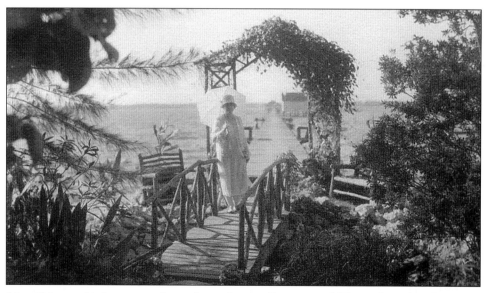

Mrs. Edison added a personal touch to almost all aspects of life at the Edison's winter estate. In this idyllic picture of wintertime in Fort Myers, Mina accentuated a variety of perspectives from the estate—botanical gardens, arched trellis, wooden walkway to pier, and the Caloosahatchee River waterfront—all of which would have been tended to personally by Mrs. Edison's staff. Though sometimes forgotten by "old-timers," Mrs. Edison worked at such tasks from her own small office at the winter estate. (EFWE.)

In the early 20th century, southwest Floridians constructed large porches to protect the main dwelling from the harsh elements and to guide breezes off the Caloosahatchee River into the house. In 1907, the Edisons ordered their own porch be expanded from 7 feet to 14 feet. The telltale expansion line is still visible on the roof of the porch. (EFWE.)

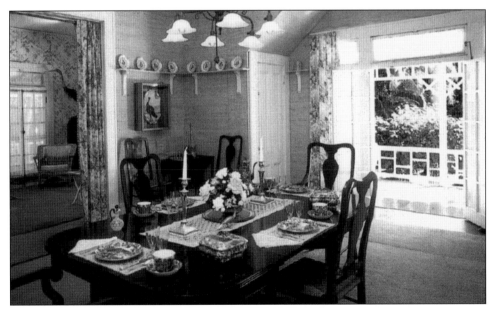

Many famous people dined with the Edisons in this room in their main house in Fort Myers. Perhaps the most frequent dinner guests were Henry and Clara Ford, who often strolled the short distance from their own home, The Mangoes, to accompany the Edisons at dinner and for subsequent evening walks and conversations. (EFWE.)

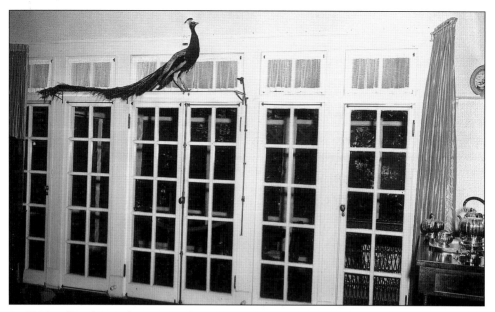

In 1930, a friend in Cuba presented an elegant peacock to Mina Edison as a gift befitting her grand winter estate in Fort Myers. Mina allowed the peacock to freely roam the grounds, which led friends to dub the bird, "the watchdog of the property." Unfortunately for this famous peacock, it ended up at Mina's taxidermist in Fort Myers, the results of which can still be seen by thousands of tourists who comment on the possible source of the curious centerpiece in the Edisons' dining room. (EFWE.)

Thomas Edison named these light fixtures "electroliers" and ordered their removal from the Edison home in Menlo Park, New Jersey to his winter estate in Fort Myers, where he supervised their refurbishing at a cost of $86 and their installation in Seminole Lodge. The Edisons' sitting parlor (also used as a game room) in the guest house of Seminole Lodge hosted one of the electroliers. Note the stuffed heron presiding over the room. (EFWE.)

In the early 20th century, lavatories were both similar and different in rather interesting ways from water closets of the early 21st century, as one can quickly determine from this picture of the downstairs lavatory in Edison's main house in Fort Myers, Florida. (EFWE.)

The Edisons placed their kitchen and food preparation area in the guest house, a short distance from their main home. In this fashion, the heat and preparation activity for their meals did not disrupt life in Seminole Lodge. One can quickly determine that this does not represent the typical kitchen of the early 20th century, given the placement of both a Roper gas oven and an electric stove in this kitchen, completed in 1907. (EFWE.)

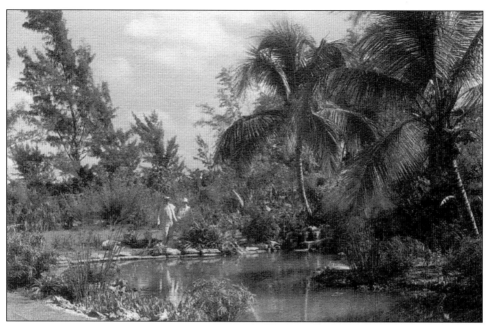

By the late 1920s, many of Thomas Edison's first plantings in his Fort Myers botanical gardens had grown to maturity. It is likely that the coconut palms Mr. and Mrs. Edison are enjoying in this afternoon stroll were planted decades earlier. By the time of Edison's death in 1931, his Fort Myers botanical gardens contained hundreds of mature plants of various species, as well as younger plants he experimented with in later life. (EFWE.)

As Thomas Edison renovated his winter estate in Fort Myers, he continuously added to his extensive botanical gardens, which were used for scientific research and decorative purposes. This "sausage tree" (Kigelia Pinnata) Edison ordered from Africa and planted in his garden continues to amaze tourists with the large seed pods that can grow up to 18 inches in length and 14 pounds in weight. (EFWE.)

This postcard from the early 20th century was meant to impress notables with the tropical setting of Fort Myers. In addition to the Edison pier, viewers could see banana trees, coconut palms, and other types of lush vegetation typical to Fort Myers in those days. Combine this portrait of Fort Myers with the name Thomas Edison, and local boosters undoubtedly felt they had a winning tourist draw for their growing city.

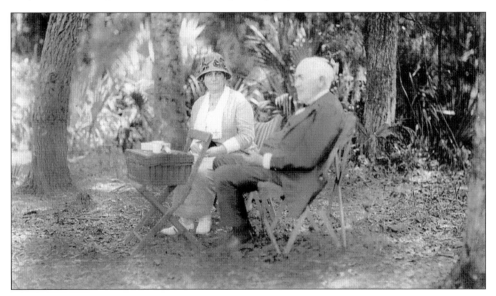

Mr. and Mrs. Edison enjoy a basket lunch on the grounds of Seminole Lodge, *c.* 1914. Mina loved flowers and plants and spent much time supervising the landscaping of the gardens and grounds at Seminole Lodge. Although routinely pursuing a rigorous work schedule, Thomas Edison often bowed to Mina's requests to take breaks, such as the one pictured here, to relax with her in the botanical gardens. (EFWE.)

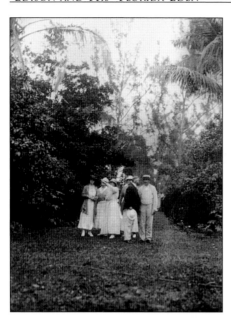

Thomas Edison and friends enjoy one of his frequent walking tours of the grounds at the Edison winter home and gardens in the 1920s. (EFWE.)

Henry and Clara Ford bought their winter residence in Fort Myers from Robert Smith of New York in 1916. The Fords became short-term winter residents in their estate, The Mangoes, situated only a short distance from their good friends, the Edisons. The Mangoes received its name from the numerous mango trees on the property, which stood out among the dozens of other citrus and exotic trees, including this Moreton Bay Fig tree in front of the Fords' winter home. (EFWE.)

Edison, impressed with the majestic royal palms of the Royal Palm Hotel in Fort Myers, offered to finance beautification of McGregor Boulevard (originally Riverside Avenue) by planting his favorite royal palms on both sides of the street. He thus originated the idea for the scenic boulevard and the subsequent moniker, "City of Palms." Pictured here about the time of Edison's "gift of trees" to the City of Fort Myers, the hotel on this postcard does, indeed, seem to offer an idyllic winter setting for those of means.

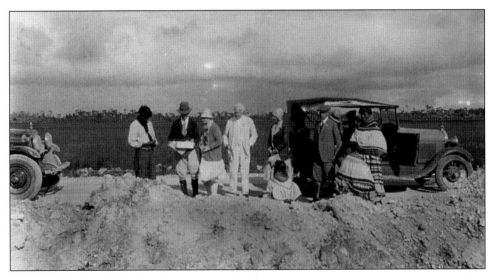

The State of Florida began the massive Tamiami Trail (Tampa to Miami road) in 1915 but halted the project due to the inhospitable terrain of Lee County. With the creation of Collier County out of Lee County in 1923, construction of the Trail resumed, with completion on April 25, 1928. Predictably, Thomas Edison the inventor, businessman, and cement mogul would have been interested in inspecting the massive project linking the west and east coasts of Florida, as he is doing in this scene in the mid-1920s. (EFWE.)

77

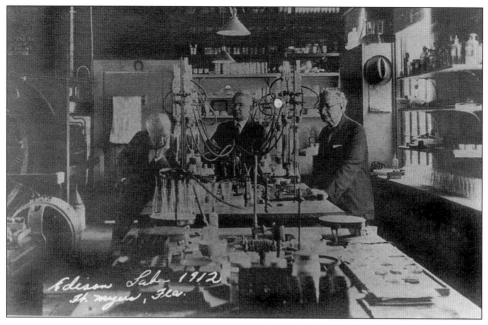

A photographer captured Edison and two colleagues in deep thought in Edison's first laboratory in Fort Myers. One can only conjecture as to what complex mechanical problem of the day so perplexed the great inventor in his electrical lab in 1912. (EFWE.)

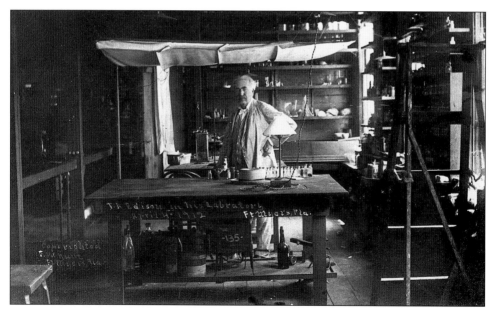

Thomas Edison is caught during a moment of contemplation while completing one of his numerous experiments in his original Fort Myers electrical laboratory, built in the mid-1880s and relocated to Greenfield Village in Dearborn, Michigan in 1928. Taken in 1912, this photograph depicts the 65-year-old inventor in the chemical station of his Fort Myers laboratory, in which he routinely worked 12- to 16-hour days. (EFWE.)

Here is a view of the workers' benches at Thomas Edison's rubber laboratory in Fort Myers. By the 1920s, Edison employed four to six workers in the lab during his winter visits to Seminole Lodge. Although the lab closed permanently to organized research upon the death of Thomas Edison in 1931, visitors to the Edison-Ford Winter Estates in Fort Myers view the facility in virtually the same condition as it appeared prior to closing. Research continued until 1934 in West Orange, with cultivation of some goldenrod in Fort Myers. (EFWE.)

Noting that the U.S. relied on foreign sources of rubber in wartime, Edison sought a domestic source of rubber in his later years. In 1927, with financial and personal support from Henry Ford and Harvey Firestone, Edison created his Botanical Research Company in Fort Myers with the mission of testing thousands of species for potential sources of rubber. Eventually, Edison determined that the domestic goldenrod plant common to southwest Florida, such as that pictured here, showed the best possibility of producing commercial rubber. (EFWE.)

Here Thomas Edison poses with a group of African-American school children near the pond on his winter estate. The Edisons routinely hired African-American gardeners and servants, many of whom lived in an area of the city adjacent to the estate known as Pinetucky. It is possible that Mina Edison invited the first class of Dunbar High School in 1927 to visit the estate, since she is known to have been a friend to her black workers in a time when the Deep South remained strictly segregated. (EFWE.)

"Look at the moon-- it winks at the world's ignorance."
Thomas A. Edison

This romantic view shows the same scene that Thomas Edison would have viewed from his electric boat, *Reliance*, a replica of which is seen in this postcard from the Edison-Ford Winter Estates in Fort Myers, Florida. Edison and family often cruised and fished the Caloosahatchee River in his battery-powered *Reliance*. Visitors to the Estates can enjoy a similar river cruise on a latter-day replica of the boat. (EFWE.)

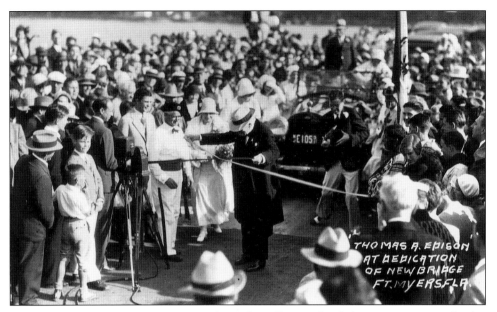

Thomas Edison, with Mina Edison to his right, officiates the dedication ceremony for the mile-long Caloosahatchee River bridge bearing his name. Civic leaders chose Edison's birthday, February 11, 1931, as the day to dedicate southwest Florida's most famous river crossing. A large number of dignitaries attended the ceremony, including local developer James D. Newton, rubber tycoon Harvey Firestone, Mayor Josiah Fitch, and Governor Doyle Carlton. The event captured both local and national headlines. (EFWE.)

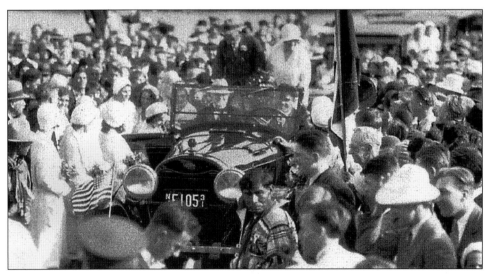

In October of 1930, Fort Myers completed the construction project, replacing its first wooden bridge spanning the Caloosahatchee River with a concrete bridge. Edison presided over the ceremony that officially opened the new "Edison Bridge" over the Caloosahatchee River. The $700,000 cost of the Edison Bridge represented a major source of employment and income for the residents of southwest Florida at that time. (EFWE.)

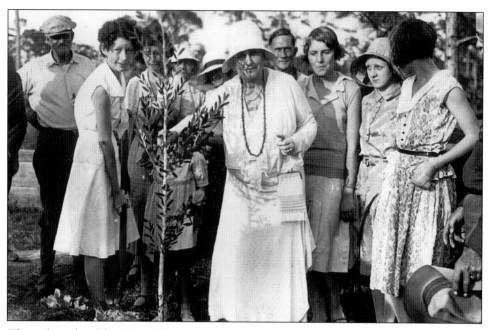

Throughout her life, Mina Edison remained active in club and civic work. Mina was close friends with Pulitzer Prize winning conservationist and cartoonist Jay "Ding" Darling with whom she also shared an interest in wildlife and tree clubs. As noted in the Seminole Lodge Guest Book, Ding Darling visited the Edisons in Fort Myers from February 22 to February 24, 1930. On frequent holidays and civic celebrations, Mina found time to participate in tree planting, as she is doing in this gathering in the 1930s. (EFWE.)

Thomas Edison often mused publicly and privately on the future of Fort Myers, Florida, home to his beloved winter estate. Recovered from the Edison-Ford Winter Estates collection, this note from Seminole Lodge in Edison's own cursive style divulged much of the renowned inventor's inner feelings about Fort Myers. Although not dated, Edison probably wrote this in the 1920s, since the U.S. Census figures did not surpass a total population of 100 million until 1920. (EFWE.)

4. Family and Friends

The greatest of all studies is human nature.

—Thomas Edison

Thomas Edison's influence on the growth, development, and culture of Fort Myers, Florida extended well past his professional contributions to science. As noted in the introduction to this book, Thomas Edison, Mina Edison, and many of the Edisons' children spent winter seasons in Fort Myers and consequently helped shape the milieu of the community. Mina Edison, in particular, came to play a major role in the civic and social life of the area, as her husband often elected to spend his days (and often nights) working long hours in his office and laboratory rather than participating in the everyday life of Fort Myers. The very fact that Thomas Edison spent many winter seasons at Seminole Lodge in Fort Myers from 1885 to 1887 and 1901 to 1931, meant, however, that the once sleepy frontier village was destined to draw national attention and notable visitors, attracted by both Thomas Edison and the tropical ambiance of this "up-and-coming" winter playground.

Though not estranged from his family, Thomas Edison often committed himself more to his work than to his spouse and children. When one considers the extraordinary productivity of this inventor and entrepreneur, it is not difficult to envision this sort of relationship between work and family. Even so, Edison experienced two successful marriages and helped raise six children, three by each marriage. While Edison's second wife, Mina, indisputably contributed the most lasting influence on Fort Myers, the great inventor's other children also played a role in the historical developments of the growing river port on the Caloosahatchee, especially third son Charles.

Edison married Mary Stilwell in 1871. When Mary died unexpectedly of typhoid fever in 1884, Edison found himself a mourning widower with three small children, Marion and Thomas Jr. (nicknamed Dot and Dash by Thomas Edison), and William. Daughter Marion later recalled about the marriage to Mary Stilwell, "Father's work always [came] first." Nevertheless, Thomas Edison remained relatively close to his children and wife, whom he referred to in his notebook as "my wife Popsy-Wopsey."

In February 1886, Edison wed Mina Miller and began his second marriage and family. Despite the two decades difference in their ages, Thomas and Mina created a trusting relationship until the great inventor's death in 1931. The second marriage, like the first to Mary Stilwell, produced three children, Charles (who became secretary of the Navy in 1939 and the Democratic governor of New Jersey in 1941), Madeleine, and Theodore. Though not noted in the history books as a committed family man, Thomas Edison did carve time out of his laboratory and related work to spend July 4th celebrations, birthdays, and holidays with his children and grandchildren. Many of the family gatherings and holiday events occurred in Fort Myers and left an imprint on the social and cultural fabric of the town. Mina and Charles, without doubt, remain Edison icons in the popular culture of Fort Myers because of their close ties to community leaders, civic groups, and other Thomas Edison–related events and ceremonies.

As with his family ties, Edison the inventor and businessman placed a low priority on close friendships. Of the lasting friendships that his records note, it was the relationships with Henry Ford, Harvey Firestone, and John Burroughs that stand out as the exceptions to Edison's stand-offish nature. He loved to share his winter retreat with these three compatriots, and thus they came, like Edison, to influence the community of Fort Myers by their very presence.

Henry Ford, the founder of the Ford Motor Company in 1903 and *Fortune* magazine's number one businessman of the 20th century, certainly stands out as the most influential of Edison's friends to conduct a lasting relationship with Fort Myers. Ford, born on July 30, 1863, near Detroit, Michigan, began working as a mechanic for various companies in Detroit, including the Detroit Edison Illuminating Company (not then owned by Thomas Edison but using his system), and like Edison spent much of his spare time in the 1880s and 1890s attempting to invent and improve practical devices, in this case a petroleum-powered quadricycle. Ford met and impressed Edison with his tenacity and ingenuity at a convention in 1896 in Long Island, New York, after which the newly inspired Ford returned to Michigan and pursued his dream of perfecting a horseless carriage. Like Thomas Edison, Henry Ford's career is now legend.

Ford set high plans for his Motor Company from its inception: "I will build a car for the great multitudes." The result was an inexpensive, mass-produced Model-T, first marketed in 1908 (a later one was presented by Ford to Thomas Edison in Fort Myers in 1916) and destined to dominate the auto market until 1927, when the "Tin Lizzie" gave way to the successor Model-A of 1928. By 1928, Henry Ford had sold 15,000,000 Model-Ts, the profits of which had vaulted him into the ranks of the world's wealthiest entrepreneurs. With these distinctions, Henry Ford joined Thomas Edison as one of the giants of ingenuity and entrepreneurship in the years marking America's greatest leap towards world economic leadership.

In 1916, the illustrious Henry Ford and his wife, Clara, purchased the house next to the Edison winter estate for $20,000. The Fords referred to their modest but comfortable winter home as "The Mangoes," because of the many mango trees adorning the property. In the late 1920s, the Fords expanded the home to include two separate servants' quarters and a guest room. The intensely private Fords used their winter home primarily for two- or three-week seasonal visits to Fort Myers, during which they spent most of their time

socializing and philosophizing with their nearby fellow snowbirds, none other than the town's unofficial Duke and Duchess, Thomas and Mina Edison. Some avocational historians claim that the Fords never returned to The Mangoes following the death of Thomas Edison in 1931, but contemporary newspaper accounts and other records indicate that the Fords did return for a few winter visits until they sold their winter home in Fort Myers to the Biggar family for $20,000 in 1945.

Both the Fords and Edisons helped attract influential people to Fort Myers. The list of such visitors includes presidents, business leaders, diplomats, and many more luminaries who otherwise might not have visited the remote town in southwest Florida. Although too numerable to list here, the names of memorable visitors to and seasonal residents of Fort Myers include oil baron Ambrose McGregor and his activist wife, Tootie; Miles Medical Company founder Dr. Franklin Miles; surgeon general of the U.S. Army during the Spanish-American War Dr. M.O. Terry; acclaimed naturalist John Burroughs; rubber impresario Harvey Firestone; and even two presidents of the United States, Theodore Roosevelt, who visited the area in 1917, and President-elect Herbert Hoover, who paid a visit to Thomas Edison in February 1929 for the golden anniversary of the electrical lamp. By the time of Hoover's visit, how many towns of under 10,000 persons could claim such illustrious visitors and benefactors? Is it any wonder, then, that the Bunyanesque legacy of Thomas Edison so permeates the life of 21st century Fort Myers, Florida?

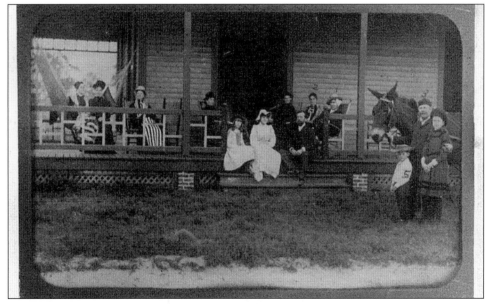

The Edison family poses for a picture on the original porch of Seminole Lodge in 1886. Thomas and Mina Edison, the newlyweds, are seated to the right of the couple on the steps to the porch. This rare picture gives a glimpse of life at the "pioneer" winter estate in frontier Fort Myers, Florida in the mid-1880s. Note that Thomas Edison's left ear is bandaged, probably as a result of one of his frequent ear infections. (EFWE.)

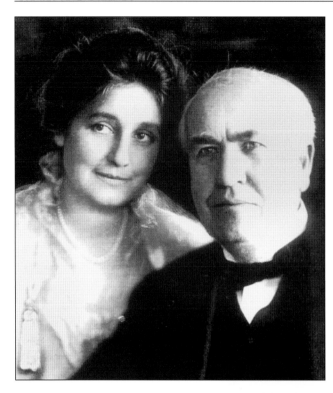

A camera captures the deeply caring couple of Mina and Thomas Edison in the early 1900s. At the time of this picture, Mina was probably in her mid-30s and Thomas in his mid-50s. They would have been married about 15 years when sitting for this portrait. (EFWE.)

Thomas Edison's second wife, Mina, won acclaim throughout her life as a devoted mother and family matriarch. Though Thomas Edison brought three prior children to their marriage, he and Mina quickly started a second family after the wedding in January 1886. That family is pictured here (minus Thomas Edison) in a professional portrait in the early 1900s. Charles (seated to the left of Mina) was born on August 3, 1890, Madeleine on May 31, 1888, and the youngest, Theodore, on July 10, 1898. (EFWE.)

The Edisons ordered a sizable expansion of their porch of the main home in 1907, thus this picture of Thomas and Mina Edison predates that event. Most likely, the photograph dates back to the early 20th century. Note the obvious age difference between Thomas Edison and his younger second wife, Mina. (EFWE.)

In the early 1920s, an unknown photographer (perhaps one of the Edisons' children) captured Mina Edison bidding farewell to Thomas as he left for work in his laboratory. One can assume this scene was recorded at daybreak since Edison worked notoriously long hours, sometimes returning home late at night and enjoying but a few hours of sleep prior to "rising with the chickens." (EFWE.)

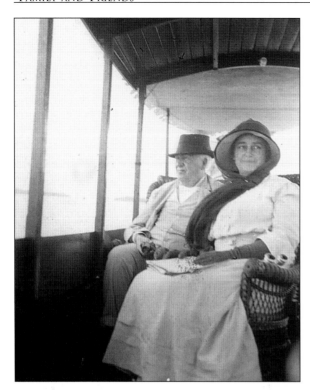

Although a workaholic, Thomas Edison often set aside time to enjoy fishing trips and sightseeing tours on the Caloosahatchee River with his wife Mina. In this c. 1925 picture, the two can be seen in their launch enjoying a picturesque day on the Caloosahatchee. Mina often recorded notes of the interesting flora and fauna of southwest Florida she and Thomas encountered on their outings. (EFWE.)

Mina and Thomas Edison relax behind their winter home, Seminole Lodge, in Fort Myers, Florida, c. 1910. They are wearing their customary formal attire, without which they seldom strayed from home and grounds. (EFWE.)

Mina Edison enjoys an afternoon chat with companions on the porch of Seminole Lodge, *c.* 1916. Mina is possibly holding a grandchild in her lap in this photograph. Mina and Thomas enjoyed entertaining family and guests on the porch of Seminole Lodge in the mild winter months of Fort Myers. (EFWE.)

Mina Edison with a companion, possibly one of her sisters, enjoys the garden of the Edisons' Fort Myers winter estate, *c.* 1915. Mina Edison personally supervised many of the local caretakers for the gardens, thus providing more free time for her husband to tend to the affairs of his laboratory in Fort Myers. (EFWE.)

Like husband Thomas, Mina Edison found joy in shepherding friends and visitors around the Edison estate in Fort Myers. Often the talk on these tours centered on social and civic themes rather than on her husband's projects. One can assume this is a topic of discussion for Mina and friends in this 1920s scene. (EFWE.)

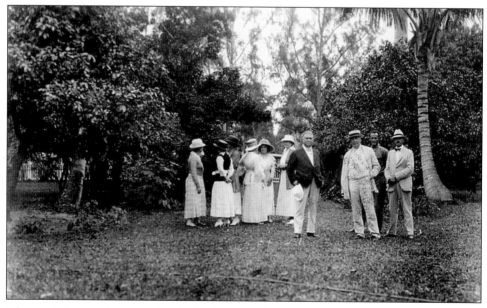

Thomas Edison took great pride in the botanical beauty of his winter estate in Fort Myers, and routinely provided guests with a walking tour of his grounds. Such is the scene here near the citrus area of the estate in the 1920s. (EFWE.)

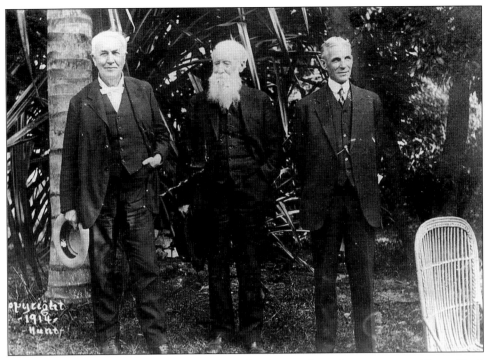

Thomas Edison poses with noted naturalist John Burroughs and auto magnate Henry Ford in the garden of Edison's winter home in Fort Myers. The picture is inscribed with the date 1914, which would make it the first group pose of the notables. The three began meeting routinely in 1916 for Edison's birthday celebration in Fort Myers. (EFWE.)

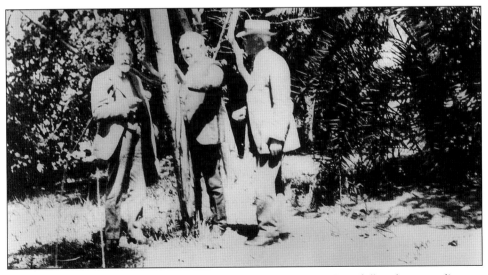

Even in later life, Thomas Edison enjoyed touring his winter "jungle" and expounding on its botanical beauty to friends and visitors. During this tour with "two gents," Edison appears to be discussing the attributes of one of his mature trees, which he perhaps planted earlier as seedlings. (EFWE.)

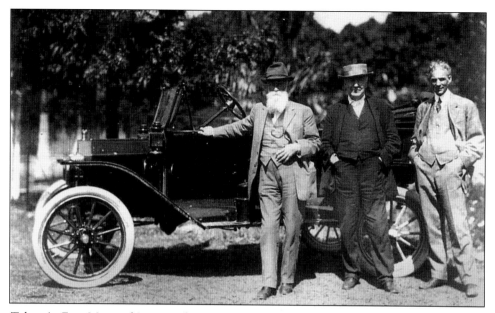

Taken in Fort Myers, this scene shows writer and naturalist John Burroughs standing with friends Thomas Edison and Henry Ford, showcasing one of Ford's famous "Tin-Lizzies." In 1914, Ford shipped three such automobiles to Fort Myers for Burroughs, Edison, and his personal use. When later asked why he didn't ship in a newer model, Ford is quoted as saying, "Why should I? A Ford never wears out." (EFWE.)

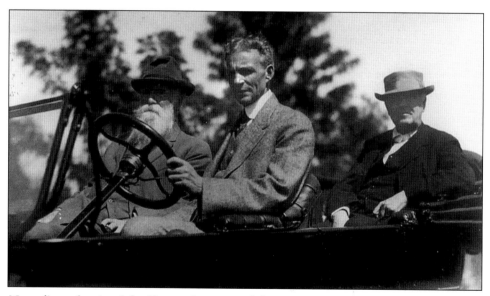

Naturalist and writer John Burroughs, automobile magnate Henry Ford, and world-noted inventor Thomas Edison spent a number of winters in Fort Myers, beginning in 1914. Often the threesome could be seen touring the town in one of Henry Ford's classic Model-Ts or traveling in the same automobiles to their Everglades camping trips. Here, the three legends of Fort Myers pose for pictures near the Edison estate, c. 1915. (EFWE.)

Thomas Edison's friends often visited his winter estate in Fort Myers for both formal and informal experiences. Acclaimed naturalist John Burroughs demonstrates his own version of both formal (as in attire) and informal (as in supine pose) behavior while visiting the Edison grounds sometime between 1915 and 1921. Perhaps Burroughs assumed this position to better view the varied bird life so common to this region. (EFWE.)

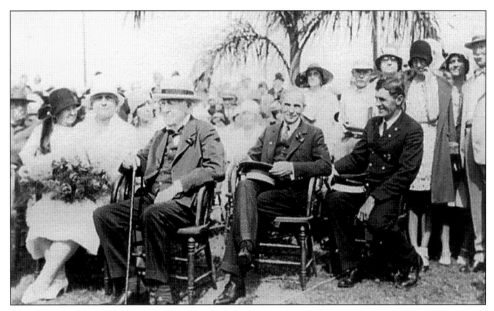

Mina and Thomas Edison, along with companions Clara and Henry Ford, often took time from their busy schedules in Fort Myers to officiate at city events, as is the case in this picture from the late 1920s. By this time, Edison was experiencing serious health problems, yet he continued to involve himself in the affairs of Fort Myers on special occasions such as this one. (EFWE.)

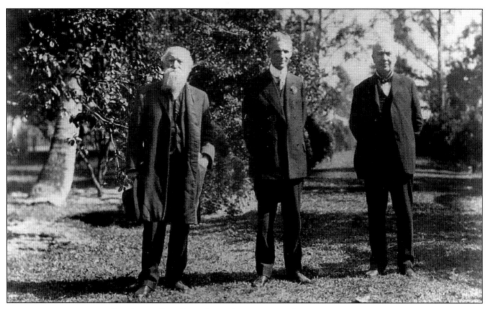

Dating from 1915, the three fast friends, John Burroughs, Henry Ford, and Thomas Edison held winter reunions in Fort Myers. Pictured here on the Edison property, the three friends in their official reunion dress (formal attire) pose for an unknown photographer, *c.* 1915. The unofficial reunions of the three companions ended with the death of John Burroughs in 1921. (EFWE.)

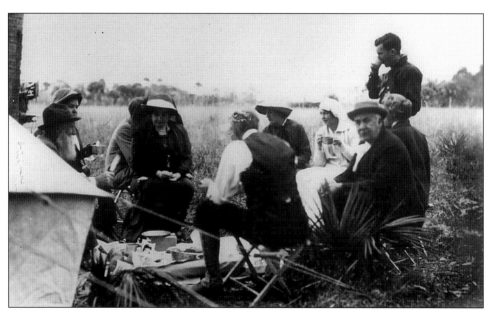

The Ford, Edison, and possibly Firestone families enjoy a lunch break at one of their "old campsites" in the Everglades, *c.* 1915. The three families often took camping retreats during the winter visits to Fort Myers. By 1921, Edison eschewed such trips, noting that they were "getting to be like a circus" because of the extensive press coverage. (EFWE.)

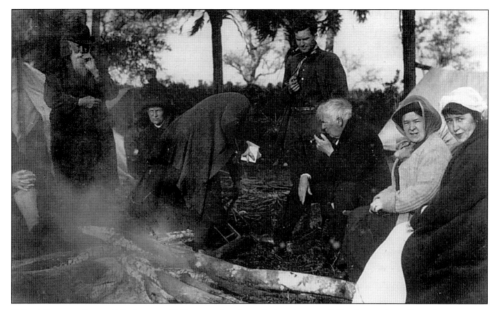

John Burroughs and Thomas Edison enjoying their cigars while "roughing" it during one of their celebrated camping trips in southwest Florida, *c.* 1915. Camping companion Henry Ford is probably just outside the frame of this picture, since his wife, Clara, is seated to the left side of Edison. (EFWE.)

Thomas Edison, Henry Ford, John Burroughs, and family and friends seem mesmerized by the fire on this camping trip to the Everglades. Note the ever-present formal attire at these events and Thomas Edison's fending off the campfire smoke, which apparently favored him among all the campers, *c.* 1915. (EFWE.)

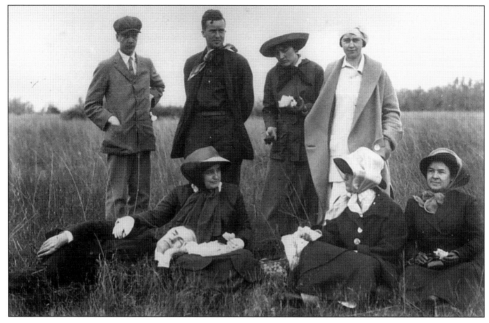

The famous inventor and ever-proper gentleman, Thomas Edison, appears a bit out of form as he is caught taking a nap on wife Mina's lap during a break from travel on an Everglades camping trip. Although present, Henry Ford remains out of lens's shot for this picture, taken between 1915 and 1921. (EFWE.)

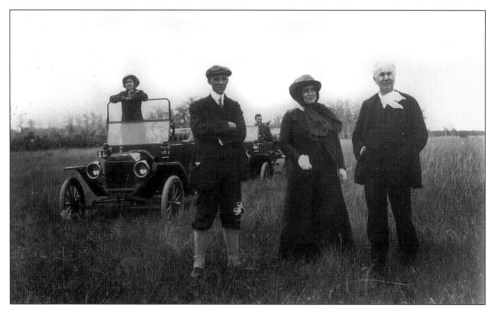

Clara Ford (standing in the "Tin Lizzie"), Henry Ford, Mina Miller Edison, and Thomas Edison pose for a picture (perhaps taken by one of the Edison children) during a camping trips to the Everglades, *c.* 1915. Although Henry Ford presented a Ford automobile to Edison in Fort Myers in 1914, it is not known whether this is that car. (EFWE.)

Between 1914 and the late 1920s, Henry Ford accompanied friend Thomas Edison on numerous camping trips in southwest Florida during their winter sojourns. An avid bird watcher, it is unlikely Ford killed the wild turkey he is holding in his right hand. It is more likely that Ford was seeking to record the size of this Everglades turkey, which might have been killed by a guide for purposes of a campfire dinner. Note the camping attire of Henry Ford, replete with Everglades spates. (EFWE.)

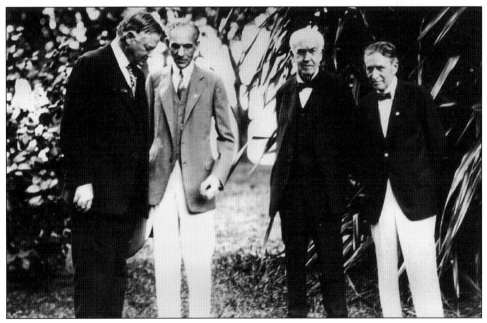

In February 1929, President-elect Herbert Hoover made a trip to Fort Myers, Florida to celebrate the "Wizard of Electricity's" 82nd birthday. Henry Ford, Thomas Edison, and Harvey Firestone confer with Hoover here prior to beginning a walking and motor tour of Fort Myers. Over 20,000 people turned out from throughout southwest Florida to pay tribute to the next president and the three American moguls as they traversed the streets of the "bursting with pride" community. (EFWE.)

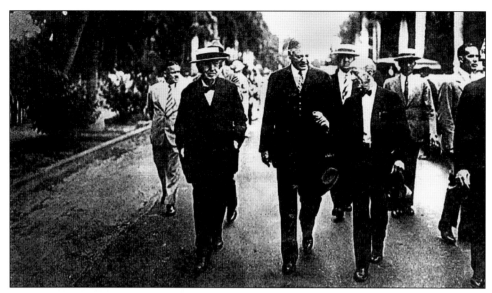

In a parade to mark Edison's 82nd birthday and the 50th anniversary of the incandescent light bulb, Edison, President-elect Hoover, and numerous Fort Myers notables greet the public on McGregor Boulevard. Following the festivities, Hoover helped the Edisons dedicate a local memorial to the golden anniversary of the incandescent light. This event won coverage in both local and national newspapers. (EFWE.)

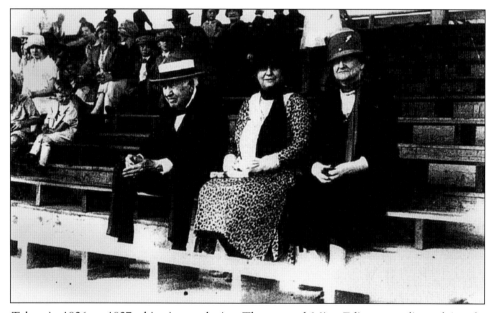

Taken in 1926 or 1927, this picture depicts Thomas and Mina Edison spending a leisurely Saturday afternoon at Terry Park in Fort Myers. This was the 1920s spring training facility for the Philadelphia Athletics baseball team under the direction of the legendary Connie Mack. Edison befriended Mack on his trips to Fort Myers and on occasion even invited him and the championship Athletics to visit the Edison winter estate. (EFWE.)

Here the legend of electricity, Thomas Edison, and the legend of baseball, Connie Mack, agree that Edison deserved a tryout with Mack's Philadelphia Athletics during spring training camp at Fort Myers. Tootie McGregor Terry donated the site for Terry Park in the memory of her second husband in 1906, and Connie Mack and the Athletics held spring training there for a number of years. (EFWE.)

Edison was fond of attending local fairs during his visits to Fort Myers. On occasion, he would invite groups from local fairs to tour his estate. Edison poses here with the "little people" from the Johnny Jones fair. This picture is from February 26 or 27, 1927. (EFWE.)

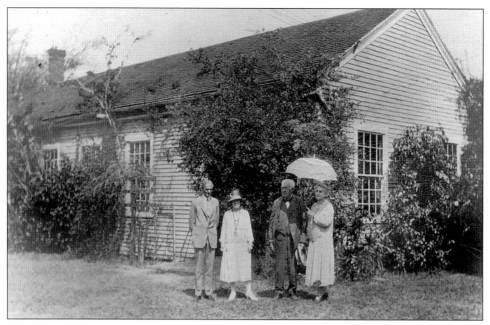

In this classic pose of the two close couples, Henry and Clara Ford pose with Thomas and Mina Edison in front of the original laboratory building in Fort Myers. Note the thick, winter foliage of southwest Florida and the glaring sun, from which Mina is shielding her husband with a parasol. This photograph probably dates from the mid–1920s. (EFWE.)

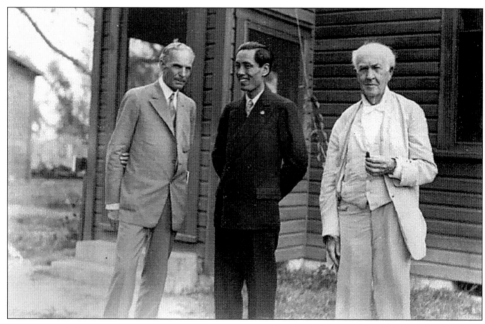

Henry Ford and Thomas Edison greet a visiting dignitary from Asia in front of the chemical/rubber laboratory, which was constructed in 1928. This photograph likely dates to 1930. (EFWE.)

Henry and Clara Ford purchased the property known as The Mangoes for $20,000 in 1916 from Robert Smith and wintered a few weeks every year there until Edison's death in 1931. The property is filled with palm trees, flowers, over 150 citrus trees, and a vegetable garden. The City of Fort Myers acquired The Mangoes in 1988 and restored it to represent the 1920s as part of the Edison-Ford Winter Estates historical site. (EFWE.)

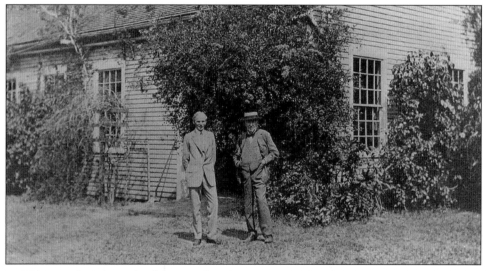

In 1927, Ford convinced Edison to allow him to move this historical laboratory to Ford's Greenfield Village historical site in Dearborn, Michigan. When Edison viewed the laboratory and the adjacent Menlo Park transplanted buildings, it is rumored that the "Wizard of Menlo Park" huffed, "You've got this just about 99 and one-half percent perfect," except "we never kept it as clean as this." The laboratory stands there today as testimony to the greatness of Ford's good friend, Thomas Edison. (EFWE.)

101

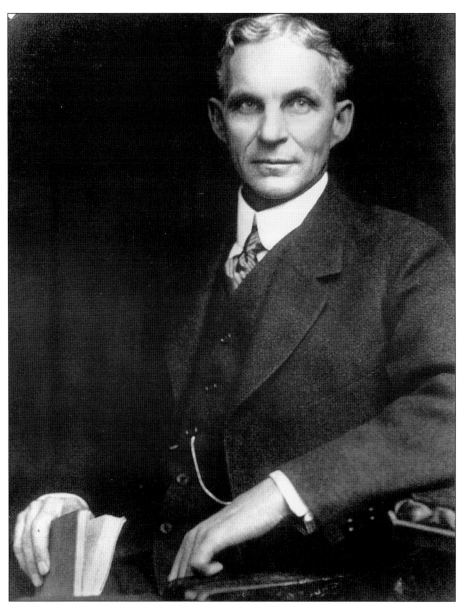

This picture found in the files of the Edison-Ford Winter Estates in Fort Myers depicts the successful and confident millionaire, Henry Ford. Ford founded the Ford Motor Company in 1903, and five years later startled America and the world with the introduction of the first mass-produced car, the Model-T. Ford's success with the "Tin-Lizzie" launched the United States into a transportation revolution, which included unprecedented changes in both motor vehicles and the roads upon which they traversed. This friend of Thomas Edison, and world-famous entrepreneur in his own right, remained a companion and supporter of "The Wizard of Electricity" for most of the years between 1914 and Edison's death in 1931. Ford, "the man who put America on wheels," died at the age of 83 in 1947. (EFWE.)

5. The Fort Myers Legacy

The future of Fort Myers is assured. . . . This City is bound to grow—and grow rapidly.

—Thomas A. Edison

Thomas and Mina Edison, and their family and friends who interacted with the one-time "cow town on the river," have immeasurably shaped the history and current life of Fort Myers, Florida. Over the years, the community's leading educators, families, and politicians have worked tirelessly to preserve the Edison heritage for all to recognize and to honor. For residents and visitors alike, the modern metropolis of Fort Myers has become almost synonymous with the name Edison through its numerous place-names and events honoring the memory of the great inventor and his much-admired wife. Thomas Edison not only forecast Fort Myers' destiny to "grow rapidly," but also contributed to that growth by his very presence there.

Even the casual observer cannot help but to notice the ever-present names and visages of the Edisons throughout southwest Florida. Those arriving by car see streets, buildings, parks, residential communities, and malls bearing the name Edison; those arriving by air see displays, tourist sites, and even taxi cabs with that name; and those coming upon the water see bridges, landings, and passageways named after the world-renowned inventor and his wife. Clubs, civic organizations, and social events reflect the Edison name and heritage. The first regional mall of the area and the now 10,000-student body community college of southwest Florida proudly display the Edison name. It does not take the wide-eyed tourist or more placid resident long to observe the blurring of the lines between contemporary Fort Myers and historical "Edisonia."

The Edison Festival of Light now reigns as the premier annual public celebration of the contributions and memories of Thomas and Mina Edison. The popular Parade of Light is the culminating event in the Edison Festival of Light, which runs about two weeks every late January through early February. Fort Myers has selected this period because it commemorates the annual birthday celebration of its unofficial Duke, Thomas Edison. Usually on a Saturday near Edison's birthday, tens-of-thousands of people turn out to view the celebration's

103

nationally famous Parade of Light through downtown Fort Myers. Beginning in 1938, the original three-day festival/procession, replete with king and queen, numerous floats, and accompanying gopher tortoise races, boat races, and sport tournaments, has wended its way down the streets of central Fort Myers to the cheers of huge crowds (the organizers suspended the event during the World War II years). Complementing the public Festival of Light is the privately run Edison Pageant of Light, which includes two dances, the King and Queen's Ball and the Coronation Ball. The Pageant also sponsors the locally festive "Mythical Realm of Edisonia," an imaginary kingdom that elects presiding royalty each season. The event and its overarching Festival of Light mark the high point of civic activities celebrating the Edison legacy in Fort Myers.

Where the Edison Festival of Light showcases the social manifestations of Fort Myers' annual memorializing of the Edisons, the Edison-Ford Winter Estates historical site attraction represents the institutionalizing of the Edison heritage. By drawing over 300,000 visitors annually, the combined winter estates of Edison and Ford attract roughly twice the number of visitors as the Edison National Historic Site in West Orange, New Jersey, situated in the very shadow of New York City. Indeed, the Fort Myers' historical attraction offers perhaps the only place in the United States where one can simultaneously observe the homes, botanical gardens, and living styles of two of America's most remarkable inventors and entrepreneurs.

This combined attraction of next-door neighbors from the early 20th century owes its genesis to Mina Edison. Thomas Edison died Sunday morning, October 18, 1931. Just prior to passing, he awoke from his coma to gaze into Mina's eyes. He told her that "it is very beautiful over there" and then closed his eyes for the last time. Mina wept for days and dedicated the rest of her life to preserving Thomas Edison's memory. She created, sponsored, or served on as honorary chairperson numerous Edison memorials, remembrances, and foundations in honor of her husband. Four years after Edison's death, Mina remarried, but stated that her new husband, Edward Hughes, was for the most part a traveling companion with whom to share time and conversation before retiring to separate bedrooms. Though always respectful of her relationship with Hughes, Mina continued to love Edison and told her personal secretary, "Dearie was the only husband I ever had."

Upon the death of Hughes in 1940, Mina, at 74 years of age, once again reverted to the Mrs. Thomas A. Edison name and devoted herself to enshrining the memory of her cherished husband. In 1946 she became the honorary chairperson of the Thomas Alva Edison Foundation, and in 1947 she deeded the Edison winter estate to the City of Fort Myers for $1. Mina's gift to the City—as "Ediphiles" recall the event—of Seminole Lodge, its botanical gardens, and Thomas Edison's final rubber laboratory were to be in Mrs. Edison's words, "a perpetual memorial to [my] husband." In the dedication ceremony on March 6, 1947, Mrs. Edison poignantly captured the spirit of the Edisons' historical connection to the city: "My faith and belief in the sincerity of the people of Fort Myers prompted me to make this sacred spot a gift to you and posterity as a Sanctuary and Botanical Park in the memory of my honored and revered husband Thomas Edison, who so thoroughly believed in the future of Fort Myers." Mina Edison died on August 24, 1947, but her intended "Sanctuary" to her beloved "Dearie" has now stood the test of time as testimony to their immortal relationship

and their equally enduring connection to the City of Fort Myers.

In the early 1980s, the City of Fort Myers began informal negotiations to acquire The Mangoes, Henry Ford's former winter home adjacent to Seminole Lodge. In 1988, the City purchased the property from Mrs. Thomas Biggar for a price of $1.5 million, a sum negotiated and finally accepted by prominent Fort Myers attorney and local heritage advocate J. Tom Smoot Jr. Thereafter the City of Fort Myers and the Edison Winter Home Board (as it was known then) approved the contract with the understanding that The Mangoes would be preserved for posterity in conjunction with the Edison Winter Estate. The Edison-Ford Winter Estates historical site attraction resulted and dramatically aggrandized the "Sanctuary" that Mina so desired for Thomas Edison prior to her death.

Through the work of Fort Myers community activists and benefactors, most notably Robert "Bob" Halgrim Sr., the Edison-Ford Winter Estates contains the largely intact winter homes of Thomas Edison and Henry Ford and one of the greatest museum collections of Edison artifacts in the world. In its highest year of attendance, 1990, the sprawling 17.2-acre site, botanical gardens, laboratory, museum, and three homes attracted 482,000 visitors. To put that figure in perspective, it represents approximately the total number of permanent residents of the greater Fort Myers area (including the booming City of Cape Coral, Florida) at the time of this writing. Mina Edison's shrine is not only institutionalized but also extraordinarily popular. Could the "man of the millennium" and the "businessman of the century" have bequeathed the City of Fort Myers, Florida anything more?

By the turn of the 21st century, the Edison-Ford Winter Estates and Museum had become a world-recognized historical site and attraction. They represented perhaps one of the few National Register of Historic Places in the United States where tourists and researchers alike could view the two sides—the public image and the personal lifestyle—of two of recent history's most recognized achievers. The Estates continues at this writing to publicize the "home" side of these men and, in so doing, preserves for future generations the educational and historical impact of the genius and ingenuity of Thomas Edison and Henry Ford.

By providing this service to the public, the City of Fort Myers, Florida, which operates the Estates, has preserved and offered for common viewing the homes and grounds of two Americans who have impacted modern life in almost unparalleled ways. Although the Estates attractions are composed of the two friends' homes, it is Thomas Edison, the "man of the millennium," and the patron saint of Fort Myers, who represents in particular a special historical connection to the former cow town on the Caloosahatchee.

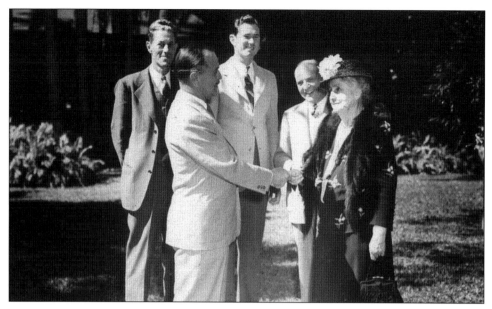

Fort Myers received its most popular historical site and tourist attraction from Thomas Edison's widow in 1947. Her goal was to create a memorial forever symbolizing the historical connection between her husband and Fort Myers. In a ceremony marking the formal exchange of the deed from Mrs. Edison to the City, Mayor Dave Shapard and other city activists accepted the "gift to the City" on behalf of the tens of thousands of Ediphiles in southwest Florida. (EFWE.)

Mina Edison's intent surfaced clearly in her attorney's proposal to the City of Fort Myers on April 23, 1946: "All this property is closely associated with Thomas Alva Edison and his work as he conducted considerable experimental research there during his winter visits. It is Mrs. Edison's desire that the property should be permanently preserved as a memorial to him." This aerial view depicts the gift as it appeared in 1947. (EFWE.)

Over 300,000 tourists annually enjoy this panoramic perspective of Seminole Lodge during tours of the Edison-Ford Winter Estates. Begun in 1885, Edison's beloved Seminole Lodge on the east bank of the scenic Caloosahatchee River hosted him and family for most of the winter seasons from 1885 to 1887, and 1901 to 1931, the year of the renowned inventor's death. Mina Edison continued to use the estate intermittently until she donated it to the City of Fort Myers in 1947. (EFWE.)

Henry and Clara Ford purchased the three and one-half acre estate, The Mangoes, in 1916 in order to spend their winter holidays in Fort Myers, but a few steps from the property's neighbors, Thomas and Mina Edison. The Fords purchased the home for $20,000 and sold it in 1945 for the same amount. Though a shrewd negotiator, *Fortune* magazine's "Businessman of the Century" did not acquire The Mangoes for profit but rather as a winter home in close proximity to the Edison's winter retreat. (EFWE.)

Visitors admire the large fish on the Edison's guest house porch. Legend has it young Charles caught the 100-pound tarpon while fishing with his father, who caught only a 40-pound tarpon that day. Wanting bragging rights as the best fisherman in the family, Charles persuaded his father to have it mounted in 1904. (EFWE.)

Although visitors are impressed with the authenticity of the Edison's winter home, few realize that the portrait of Mina Edison was added well after her death. Nevertheless, the Edison's living room at Seminole Lodge offers an exciting historical window into the years of its use by the great inventor and his wife. Note the original electrolier, the popular Florida wicker furniture, and the baby grand piano, which Mina so cherished. (EFWE.)

Visitors to the Edisons' home in Fort Myers, Florida have the opportunity to walk under the breezeway between Edison's main house and the guest house. This picture of that porch-to-porch walk dates back to 1931. (EFWE.)

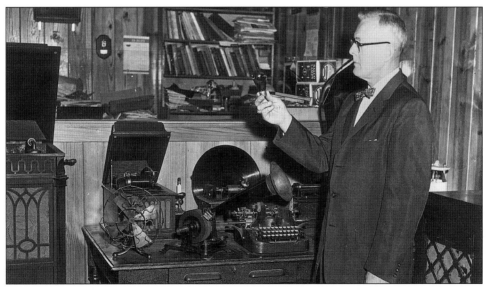

From the time the City of Fort Myers acquired the former winter estate from Mina Edison in 1947, Robert Halgrim Sr., who knew the Edisons, worked tirelessly to acquire as many of Edison's personal and professional memorabilia as possible. Devotees of Edison's memory look upon Bob Halgrim as the person most responsible for the extensive artifacts and displays in the Estates' Museum. In this 1950s photograph, Halgrim inspects newly arrived Edison artifacts. (EFWE.)

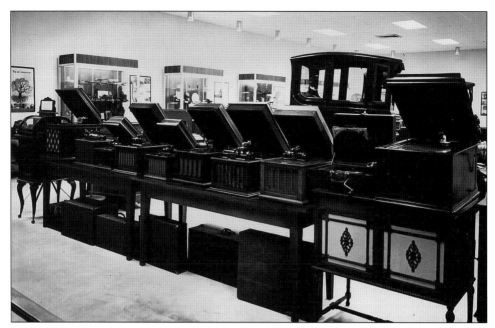

In 1877, Thomas Edison made a startling discovery while working in his lab. He noted to a co-worker, "I believe if we put a point on the centre [sic] of that diaphragm and talked into it whilst we pulled some of that waxed paper under it so that it could indent it, it would give us back talking when we pulled the paper through the second time." From this use of the modern scientific method, Edison created his "favorite invention," the phonograph, for which he received almost 200 patents. (EFWE.)

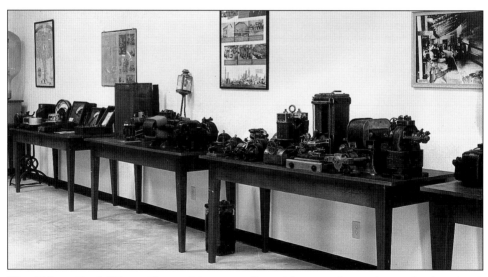

The Edison-Ford Winter Estates Museum offers visitors an interesting and educational display of Edison's original electrical powering and measuring devices, for which he gained much acclaim. These are timeless reminders of Edison's moniker, "Wizard of Electricity," a well-earned title that brought him worldwide celebrity status. (EFWE.)

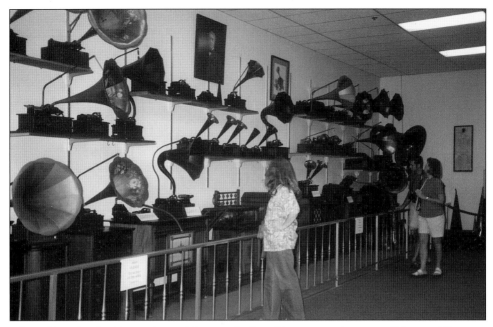

The Edison-Ford Winter Estates Museum in Fort Myers contains one of the world's most extensive displays of Edison–designed phonographs. The models range from 1878- to 1929-versions of Edison's phonographs, including both cylinder and "diamond disks" record machines. (EFWE.)

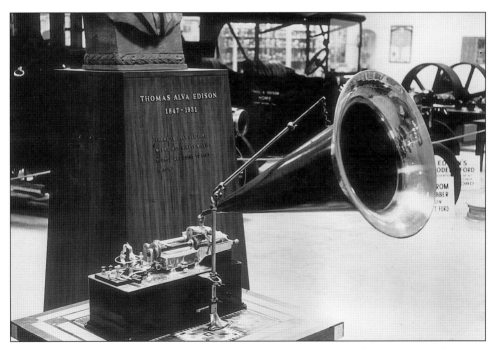

This Edison phonograph display and small bust are showcased at the Edison-Ford Winter Estates Museum. In the background is one of the era's Ford automobiles. (EFWE.)

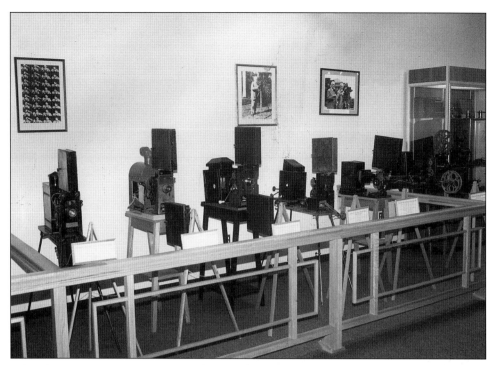

Edison's motion picture cameras and projectors are on display at the Edison-Ford Winter Estates Museum. This one of the most extensive of such displays in the world. (EFWE.)

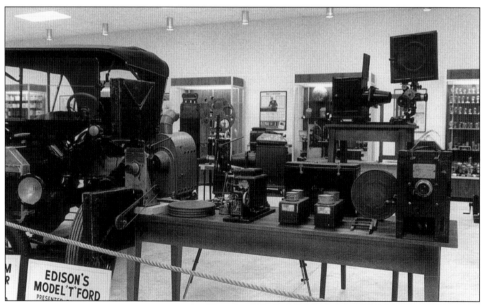

To the right of Thomas Edison's Model-T Ford is a display of models of Edison's pioneering motion picture equipment. The display cases in the background contain numerous Edison memorabilia, much of which Robert Halgrim Sr. collected during the early decades of the historical site. (EFWE.)

Thomas Edison's winter estate automobiles offer an intriguing backdrop to his early filmmaking devices. Situated in the lower left corner is an Encyclopedia Britannica film on Edison, titled *Wisdom*. (EFWE.)

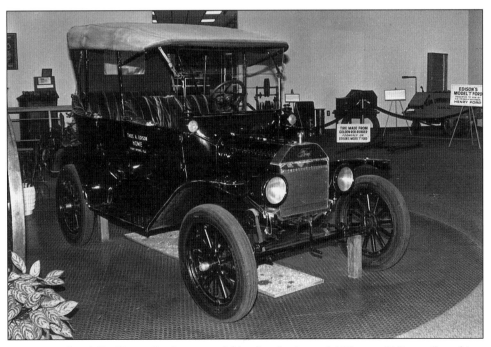

In 1916, industrialist Henry Ford presented friend and role model Thomas Edison a "spanking new" Model-T Ford automobile. Today, that automobile is on display in the Museum of the Edison-Ford Winter Estates. (EFWE.)

Bob Halgrim (to the immediate left of the bust) and Charles Edison (to the immediate right of the bust), son of Thomas and Mina Edison and former Democratic governor of New Jersey, pose for pictures at the smaller of two Edison busts in the Edison-Ford Winter Estates Museum. Charles Edison, who died in 1969, often visited his father's estate in Fort Myers and posed for pictures like this one, taken in the mid-1960s. (EFWE.)

A former friend of the Edisons and the first curator of the Edison Museum in Fort Myers, Bob Halgrim worked for over 20 years to transform the winter estate, second laboratory, and new museum into a world-class showcase of Edison inventions and memorabilia. Halgrim is seen in the 1960s in front of the Estate's sprawling banyan tree, which was presented to Edison as a seedling from India by Harvey S. Firestone in the 1920s. (EFWE.)

To celebrate the legacy of Thomas Edison's seasonal visits to Fort Myers, the city had a long-standing tradition of launching special municipal events with a display of Edison's own Model-T. Prior to the year 2000, when it was retired, the vintage Ford often served as the lead vehicle for the Edison Pageant of Light, as can be seen in this procession in the early 1960s. (EFWE.)

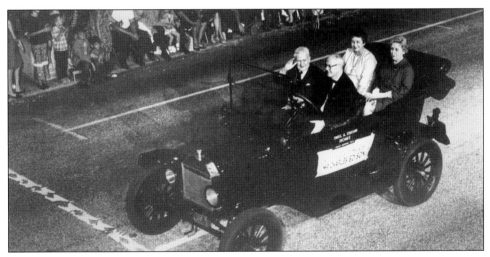

Charles Edison (former secretary of the Navy and Democratic governor of New Jersey) frequently visited Fort Myers, in a personal and professional capacity to launch or sanction events in honor of his father. Driven by Bob Halgrim in Thomas Edison's historical Ford automobile, Charles Edison waves cordial greetings to the crowds near First Street gathered to greet him and the procession of floats, King and Queen, princes and princesses, and dukes and duchesses of Edisonia. (EFWE.)

Hurricane Donna swept through southwest Florida on September 10, 1960, leaving in its wake extensive damage. Practically every ground-level building in Fort Myers sustained some form of damage, including the historic Edison winter home on the waterfront of the Caloosahatchee River. As fate would have it, the Edison property experienced only minimal damage, as witnessed in this contemporary photograph. Within three weeks, the City had completed the clean up and repair and had reopened the site. (EFWE.)

In this undated photograph, Thomas Edison's most famous son, Charles, assists in the unveiling of a bust in honor of his father in the Estates Museum. Probably taken in the mid-1960s, this scene reflects one of many at which Charles Edison participated in at his parents' former winter retreat. Charles Edison won acclaim himself as a former secretary of the Navy, Democratic governor of New Jersey, and as a lifelong booster of the memories of his famous parents. (EFWE.)

Local residents of Fort Myers often recorded in their family histories seeing the "Wizard of Menlo Park" cruising up or down the Caloosahatchee River in his sleek electric boat, the *Reliance*. Twenty-first century visitors to the Edison-Ford Winter Estates can ride a replica of the *Reliance*, weather permitting, and thus share in one of Thomas Edison's favorite experiences during his winter visits to Fort Myers. (EFWE.)

One of the pausing points of a typical tour of the Edison-Ford Winter Estates Museum in Fort Myers is the massive bust of Thomas Edison. As many as 350,000 tourists admire this stately portrayal of the "Wizard of Menlo Park" every year. (EFWE.)

This bust of Thomas Edison is a favorite picture stop for tourists at the Museum of the Edison-Ford Winter Estates. Even young children still stand in awe of the great inventor whose visage commands such respect at the Museum. (EFWE.)

With one of the world's largest collections of Edison phonographs as the backdrop, the staff of the Edison-Ford Winter Estates conducts a ceremony for a valued employee. On the left, Museum Store manager Ken Johns and (second from left) Estates director Judith Surprise make the presentation. The Estates hosts educational programs and services for schools and Florida Gulf Coast University, which has held its Southwest Florida history class, taught by the author of this book, there on numerous occasions. (EFWE.)

Edison's light bulbs are on display at the Edison-Ford Winter Estates Museum. This is one of the most extensive displays of Edison's "electric lamp" in the world. (EFWE.)

Every winter, the Edison-Ford Winter Estates conducts Holiday House, during which the structures are festooned with seasonal decorations. Originally running from the first Friday in December and lasting for ten days, the event now runs through December 30. Each Holiday House season, the Ladies Club of Fort Myers supervises the event, which draws about 45,000 visitors. The public is free to follow the walkways for a nominal fee from 5 p.m. to 9 p.m., enjoying the holiday lights in the early evening hours. (EFWE.)

The Edison-Ford Winter Estates currently draws over 300,000 visitors annually. This figure represents more than twice the number of recorded visitors at the Edison National Historic Site in West Orange, New Jersey. This group is listening to a guide explain the significance of the royal palm trees that so stately reign over Seminole Lodge and border McGregor Boulevard in Fort Myers. (EFWE.)

The Edison-Ford Winter Estates guided tour offers visitors an opportunity to acquire background information on Henry Ford's side of the attraction and to view, as in the case here, a Henry Ford re-enactor. Although recalled most often for his automobile success, Ford also produced such items as "flivver tanks," Eagle Boats, airplane engines, gliders, jeep assemblies, generators, bimotor airplanes, racing cars, and Great Lakes freighters, all of which contributed to his being selected in 1999 as *Fortune* magazine's "Businessman of the Century." (EFWE.)

Historians have surmised that Edison first visited Fort Myers in search of the local, giant bamboo from which he hoped to extract a working filament for his incandescent light. Edison was a complex man, and it is probable that both the local bamboo and a combination of other factors lured him to Fort Myers. In the wintertime, as is the case here, tourists to the Edison-Ford Winter Estates observe patches of bamboo like this one reminiscent of the early days of Fort Myers. (EFWE.)

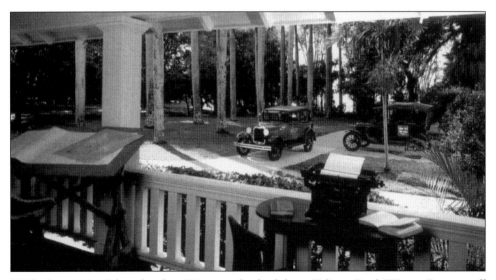

With the scenic Caloosahatchee River as the backdrop, Edison-Ford Winter Estates staff move vintage cars from their nearby storage area toward the porch of The Mangoes for a special event. The vehicles are housed in the Fords' garage on the property and are a favorite conversation point for visitors to the Estates. By mass-producing this popular vehicle on the Ford assembly lines, it is estimated that the Ford Motor Co. earned $7 billion in Henry Ford's lifetime. (EFWE.)

This stairway leads to Thomas Edison's second and final laboratory building, the chemical lab, on his winter estate in Fort Myers, Florida. Visitors to the Estates may tour the lab and take photographs of Thomas Edison's final "invention factory." (EFWE.)

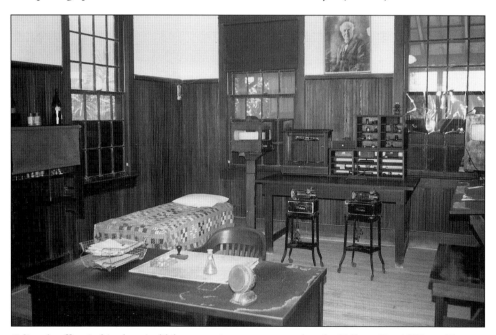

Edison's office in his chemical laboratory is now preserved at the Edison–Ford Winter Estates. In addition to the equipment, the office contains a cot. As stories go, Mina Edison presented the cot to Thomas in his later years so that the inventor would not have to sleep on benches or worktables as he did throughout much of his adult life. (EFWE.)

Although it looks as if these tourists at the Edison–Ford Winter Estates are traversing in front of a patch of forest, they are actually moving in front of only one section of the giant banyan tree on the property. What appear to be trees sprouting from the ground are aerial roots forming over the years since the original planting in the 1920s. The Florida State Historic Marker at the center of this picture explains the historical significance of the original Edison winter estate. (EFWE.)

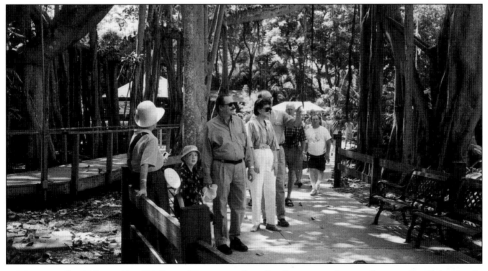

Visitors to the Edison–Ford Winter Estates undertake the unusual experience of walking both underneath and through the large banyan tree between the parking area and the museum building. Springing from the original four-foot cutting, "the Edison banyan" has grown over the years to a startling 400-foot circumference, making it a rival for the world's third largest banyan tree. If not pruned regularly, this behemoth could someday engulf the eastern quadrant of the Edison–Ford Winter Estates historical site. (EFWE.)

This statue is near the entrance to the Edison-Ford Winter Estates on McGregor Boulevard. The Edisons joined their young friend James Newton, developer of Edison Park, on April 7, 1926 for the development's grand opening. They are remembered today as four icons of Fort Myers' history and culture: Thomas Edison, Mina Edison, James Newton, and "Rachel" (the statue). In 1987, Newton wrote *Uncommon Friends*, a best-selling book describing his unique friendship with the Edisons, Henry Ford, Harvey Firestone, Alexis Carrel, and Charles Lindbergh. Newton's book inspired an award-winning video documentary (narrated by Walter Cronkite) and moved civic activists of Lee County, Florida to create the nonprofit Uncommon Friends Foundation, whose mission is "to educate people of all ages to develop certain personal traits—a spirit of adventure, sense of purpose, unending personal growth, and commitment of helping friends—that James D. Newton observed in the lives of his five *Uncommon Friends*, and to understand the historical significance of the *Uncommon Friends* in shaping the modern world." By the early 20th century, the Uncommon Friends Foundation had emerged as a leading philanthropic and historical awareness organization in southwest Florida.

Located in Centennial Park on the banks of the Caloosahatchee River in downtown Fort Myers, the "Friends" sculptures and fountains provide an idyllic setting for tourists and locals alike. The sculptures are of Henry Ford, Harvey Firestone, and Thomas Edison in an informal and friendly scene, most likely one of the camping trips in southwest Florida, which lasted until Edison's infirmities in later life prevented this kind of activity.

Florida Gulf Coast University opened for students in the fall of 1997 as Florida's tenth state university and Southwest Florida's major institution of higher education. Here, FGCU's second president, Dr. William C. Merwin, greets students during fall registration. Merwin, who is also a professor of history, has facilitated close ties and a groundbreaking internship program with the Edison-Ford Winter Estates as part of his emphasis on FGCU offering pioneering courses in Southwest Florida history and related "town and gown" activities.

EDISON GENEALOGY

Nicholas Stilwell m. Rebecca Bayles
(1640-1715) m. C. Huxberts Morgan
m. Elizabeth Cornell

Thomas Stilwell m. Ann _____
(1680-) m. Catrina _____

Nicholas Stilwell m. Martha _____
(1712-1780)

John Stilwell m. Mary Mulliner
(1735-1799)

Nicholas Stilwell m. Jemina Aber
(1774-1854)

Mary Stilwell (1855-1884)

John Edison m. Sarah Ogden
(1727-1814)

Capt. Samuel Edison m. Nancy Simpson
(1767-1865)

Samuel Edison, Jr. m. Nancy Elliott
(1804-1896) (1810-1871)

Marion W. Edison (1829-1900)
m. Homer Page

William Pitt Edison (1831-1891)
m. Nellie Holihan

Carlile Edison (1836-1842)

Harriet A. Edison (1833-1863)
m. Samuel Bailey

Samuel O. Edison (1840-1843)

Eliza S. Edison (1844-1847)

Thomas Alva Edison (1847-1931)

Abraham Miller m. Catherine Clopper
(1749-) m. Elizabeth Clopper
m. Sabilla Lauer

John Miller m. Elizabeth York (1805-1883)
(1786-1875) m. Elizabeth T. Auhtman
(1787-1885)

Lewis Miller m. Valinda Alexander
(1829-1899) (1830-1912)

Mina Miller (1865-1947)

Mina Miller m. Thomas A. Edison
(1865-1947) (1847-1931)

Mary Stilwell m. Thomas A. Edison
(1855-1884) (1847-1831)

Thomas A. Edison, Jr. William L. Edison
(1876-1935) (1878-1937)
m. Marie L. Toohey m. Blanche F. Travers
m. Beatrice Heyzer Montgomery

Marion E. Edison
(1873-1965)
m. Oscar Oeser

Madeleine Edison Charles Edison Theodore Edison
(1888-1979) (1890-1969) (1898-1992)
m. John Erye Sloane m. Carolyn Hawkins m.Anna M. Osterhout

Selected Edison and Associated Sites

Edison-Ford Winter Estates
2350 McGregor Boulevard
Fort Myers, FL 33901
(941) 332-6634
www.edison-ford-estate.com/index2.php3

Edison National Historic Site
Main Street and Lakeside Avenue
West Orange, NJ 07052
(973) 736-0550
www.nps.gov/edis/home

Edison Plaza Museum
350 Pine Street
P.O. Box 2951
Beaumont, TX 77704
(409) 839-3089
solstice.crest.org/renewables/eerg/epm

Henry Ford Museum & Greenfield Village
20900 Oakwood Boulevard
Dearborn, MI 48124-4088
(313) 271-1620
www.hfmgv.org/index2

Port Huron Museum
1115 Sixth Street
Port Huron, MI 48060
(810) 982-0891
www.phmuseum.org/home

Thomas A. Edison Memorial Tower
37 Christie Street
Edison, NJ 08817
(732) 549-3299
www.edisonnj.org/menlopark/museum.asp

Thomas Edison Birthplace
9 Edison Drive
Milan, OH 44846
(419) 499-2135
www.tomedison.org

Thomas A. Edison Papers: edison.rutgers.edu

Thomas Alva Edison in Menlo Park, NJ:
www.jhalpin.com/metuchen/tae/taeindex

Thomas Edison Patents: edison.rutgers.edu/patents

Selected Bibliography

Conot, Robert. *Thomas A. Edison: A Streak of Luck.* New York: Da Capo Press, Inc., 1979.

Grismer, Karl H. *The Story of Fort Myers: The History of the Land of the Caloosahatchee and Southwest Florida.* Fort Myers Beach, FL: The Island Press, 1982.

Israel, Paul. *Edison: A Life of Invention.* New York: John Wiley & Sons, 1998.

Josephson, Matthew. *Edison, A Biography.* New York: John Wiley & Sons, 1959.

Lewis, David L. *The Public Image of Henry Ford.* Detroit: Wayne State University Press, 1976.

Milanich, Jerald T. *Florida Indians and the Invasion from Europe.* Gainesville: University Press of Florida, 1995.

Newton, James D. *Uncommon Friends: Life with Thomas Edison, Henry Ford, Harvey Firestone, Alexis Carrel, and Charles Lindbergh.* San Diego: Harcourt Brace Jovanovich, 1987.

Solomon, Irvin D., and Grace Erhart. "Race and Civil War in South Florida." *The Florida Historical Quarterly* Vol. 77 (Winter 1999): 320–341.

———. "Southern Extremities: The Significance of Fort Myers in the Civil War." *The Florida Historical Quarterly* Vol. 72 (October 1993): 129–152.

Tebeau, Charlton W., and William Marina. *A History of Florida.* Coral Gables, FL: University of Miami Press, 1999.

Williams, Lindsey Wilger. *Boldly Onward: The Incredible Adventures of America's "Adelantados" and Clues to Their Landing Places in Florida.* Charlotte Harbor, FL: Precision Publishing Co., 1986.